SOUTH DAKOTA
WINE

SOUTH DAKOTA WINE

WINE

A Fruitful History

DENISE DePAOLO *and* **KARA SWEET**

FOREWORD BY BOB WEYRICH

AMERICAN PALATE

Published by American Palate
A Division of The History Press
Charleston, SC
www.historypress.net

Cover images: Front image courtesy of Belle Joli' winery. Back cover image of snowy vineyard courtesy of Bob Weyrich.

First published 2017

Manufactured in the United States

ISBN 9781625858436

Library of Congress Control Number: 2017938336

Notice: The information in this book is true and complete to the best of our knowledge. It is offered without guarantee on the part of the authors or The History Press. The authors and The History Press disclaim all liability in connection with the use of this book.

CONTENTS

FOREWORD

From a layman's perspective, appreciating wine can be seen as merely an epicurean pastime or perhaps even wine snobbery. Yet the enjoyment of wine quite transcends what we pour out of the bottle. It echoes both the ingredients and the vintage. And in South Dakota, it also signals the language of the shoulders of the Missouri River and the feet of the Black Hills.

The tradition surrounding wine in our region can be traced back at least two hundred years. Following the Louisiana Purchase in 1803, President Thomas Jefferson commissioned a group of volunteers to explore the newly acquired land. These volunteers, led by Meriwether Lewis and William Clark, were charged primarily with the tasks of mapping the annexed territory and finding a water route that traversed it. The literature concerning the expedition's path through the Great Plains made numerous references to various species of grapes, including *Vitis riparia* (wild grapes). The expedition also made note of additional grape species and various other fruits that had been growing amid the prairie grasslands and the Missouri River Valley, which bisects South Dakota.

European settlers came to this area in the latter half of the 1800s from countries with latitudes similar to those of the Dakotas. They proved up on homestead claims with tenacity and assiduous work and were able to survive and even flourish. The skill set of the commonplace Dakotan pioneer had to include various abilities out of necessity, but the ability of winemaking was likely pursued out of passion. The austerity of the hills and prairies—and

possibly the isolation the settlers felt—inspired their resourcefulness. The long, cold winter nights galvanized early Dakotans toward self-reliance. They gathered, grew and produced anything they were able to when resources were plentiful and made the best of their new environment for the days when the sun didn't shine. In those days, a single miscalculation in planting or failure of a single crop could mean the difference between a comfortable winter and starving to death.

Despite all the uphill battles, the earliest winemakers (either the homesteaders or hobbyists) turned to other products in their backyards. Plants such as the plentiful chokecherry, the hardy currant, the implausible rhubarb and the wily buffaloberry allowed them to capture not only a crop but also a season and a time when the sun was shining and the warm days were plentiful.

Years later, Dr. Ron Peterson at South Dakota State University scoured the same river trails and prairies to find the wild grapes that Lewis and Clark had mentioned in their accounts. Dr. Peterson knew that the wild varieties had sustained in the harsh climates of the Dakotas and Montana. Peterson's early work to develop a hardy hybrid indeed produced the Valiant grape. It also furthered the understanding of what allowed species to survive in the harsh winters yet bear the fruits we have come to know now.

A few pioneering spirits in various corners of the state, like the Schades and the Jacksons, planted various grape varieties in their vineyards. They planted vines, erected trellises, fought weeds, replanted vines, pruned stalks, irrigated vines, replanted again and birthed commercial vineyards. All these struggles and tireless contributions gave wineries something that was, at least, familiar to the region.

After the enabling legislation was passed in 1996, Winery Number One received the legal authority to make and sell wine. Others followed, and production began to grow, slowly at first. The earliest winemakers schlepped their wine to retailers. They gave away samples to convince people winemakers had something worthy. They offered bottles of wine and included stories of the vineyard or how they had picked plentiful chokecherries last season. They found eager audiences that remembered a favorite wine that their uncle or grandmother had made years ago. The drinkers imbibed in the good times and relaxed a little in the present.

The contemporary hybrid cultivars of Frontenac and Brianna, as well as newer varieties including Marquette and Petite Pearl, are on their way to proving their worth to the area's winemakers. Vineyards still battle through

intensely cold seasons, with early breaks in dormancy and late freezes, followed by short, hot and arid growing conditions.

Whether they started out in the garage, basement or barn, winemakers in the state thirsted for the science behind what allowed them to make wine utilizing all the character of what each season delivered. When grapes begin their ripening, acids will dissipate and sugars and varietal flavors will develop. In South Dakota, a cool season, the threat of an early frost or even impatience with the process will compromise how good a crop can be. It takes an artist to ply his or her knowledge and experiences to produce fine wines with these ever-changing media.

The wine artists started commanding attention. Their hard work, their stories and their bottled-up experiences lured those seeking a soft and mellow transition from their normal distilled indulgences or everyday carbonations. Experienced wine drinkers held their noses in the air until their senses found some similarities to a Riesling and the allure of something that wasn't grown in California.

Wine became vogue on the prairies and in the small towns that were starved for something they could call their own. Honey was fermented, and local fruits colored the legacy of light, sweet clover. Prairie fruits bursting with all the season's nuances challenged even the most experienced winemaking knowledge. The indifference of rhubarb led customers to a whimsical or serious appreciation of what people had enjoyed in a pie from grandma's wood-fired oven.

Neighbors now had something they could relate to and boast about to visitors. And they did. They talked about the plentiful wild plums last year. They bragged about the winery down the road. They sipped some new acquaintances like the hybrid grapes St. Pepin, Kay Gray and La Crescent. Some of those early friends were passed up as growers leaned toward favorites and their wisdom-tempered older vines.

The state's wineries have come into their own. Quite a few varieties and winery offerings are featured in local liquor stores and wine shops. Tried-and-true varieties are patiently anticipated with each new offering that we love or might leave for a different time. In 2015, legislation allowed direct shipments to in-state customers, for both South Dakota wines and wines from all over.

Up and down sales trends can mimic the natural challenges to the fruits that make the wines. The state's wineries, and those all over the country, are being challenged by other fermentation. Some of the same elements from the wine world segue into malt-based products. Fruits, wild yeasts and beer

aged in wine barrels blur the once easily defined boundaries. Hard ciders have enjoyed huge growth in popularity. Is cider a beer…or is it a wine?

Nonetheless, wineries are rising to the occasion and getting their second wind. Sparkling offerings are looking to fuse traditional Champagne methods with atypical grapes grown in South Dakota. New wineries are catching the essence of soils, climates and personalities that may reveal future viticultural regions.

Open a bottle of a South Dakota wine. Taste the grasslands, savor the hillsides and remember some of those who went before and allowed their passions to linger.

—BOB WEYRICH

ACKNOWLEDGEMENTS

S aying thank you for a project like this seems like a daunting task. The fear of leaving someone out is real, and we will try our hardest not to forget those who worked so diligently to help us in this labor of love that supports our two favorite things: the state of South Dakota and wine!

The people in this business have been so helpful. No matter what we asked for or when we asked for it, supporters of this industry stepped up to give us information, pictures, interviews, contacts, numbers and so on. Grape growers, winemakers, marketing directors and tasting room members were more than accessible to us at all times, often giving even more than we asked.

The grape growers and winemakers all over the state who have worked tirelessly to make wine also worked tirelessly to help us tell their stories: Eldon Nygaard, the Nygaard family and the staff of Valiant Vineyards; Choi, Matthew, Patty and John Jackson of Belle Joli' Winery and Sparkling House; the Firehouse Wine Cellars family: Mike and Marnie Gould, Bob Fuchs, Michelle Pawelski and Megan Johnson; Don and Susie South at Strawbale Winery; Jim and Nancy Schade and Dillon Ringling of Schadé Vineyard and Winery; Dave and Sue Greenlee at Tucker's Walk Vineyard; Sandi and Ralph Vojta, Emily Paulson and Andrea Stalheim of Prairie Berry Winery; Rob Livingston of Naked Winery; Victoria and Jeff Wilde at Wilde Prairie Winery; and Jeremiah and Lisa Klein of With the Wind Vineyard and Winery.

Many on the periphery of the industry also showed great support for the venture. Bob Weyrich, author of our foreword, was a great resource

and is such a supporter of this growing industry. Dr. Anne Fennell at South Dakota State University (SDSU), Mitch Krebs of the South Dakota Wine Growers Association, Ara Baumstarck of Black Hills and Badlands Tourism Association and Bobbie Jo Tysdal and Amanda Williams of the Anna Miller Museum all gave time, effort and information to show the past, present and future of the growing wine business in the state.

Of course, our families must also be thanked. Kara's husband, Brian, and children, Ashlyn and Colton, deserve much appreciation for the many wineries and vineyards all over the area they have had to visit, even before this project. It has been a work in progress, and Brian, Ashlyn and Colton have definitely been there for every step of the progress.

Denise's husband, Tony, and mother, Jan, deserve all of the gratitude in the world. Their support during this project was immense and will always be appreciated. As will the cooperation of Mia, who spent the first summer of her life visiting vineyards and wine festivals and picked her first Frontenac grapes at six months old.

Finally, thank you to those who believe in this industry and drink South Dakota wine. Tell your friends. Spread the word. Support the grape growers, winemakers and tasting rooms in this state. It truly is exciting to see what the next twenty years will bring to Mount Rushmore State wine.

INTRODUCTION

As my co-author, Kara Sweet, and I began working on this project, South Dakota's wine industry was celebrating its twentieth anniversary. Over the two decades since the 1996 passage of the Farm Winery Bill by the state legislature, winemaking has moved out of the basement and evolved into an industry two dozen wineries strong—and growing.

Creating something out of nothing is always a challenge, but working toward a goal while being told your task is impossible can be particularly daunting. While shopping at the local ag supply store, prospective winemakers were told that the soil here wasn't right for grapes. They were warned that the climate was too harsh, too erratic. It rained too much, too little, hailed too frequently. Consumers wouldn't be interested in wine that wasn't the standard California or French issue. They would be better off growing corn and soybeans or raising cattle like everyone else.

They proved the naysayers wrong. It takes a stubborn sort—an industrious, tireless, resourceful type of person—to pioneer an industry. But those who thought grape growing and winemaking would never succeed in South Dakota appear to have forgotten who these people's ancestors were. They came from the East, oftentimes fresh from a months-long transatlantic journey, to an open prairie of vast, dense grass and made a life for themselves among strangers. They brought with them only a spark of hope and the scant contents of their wagons and built their homes from blocks of that same rich earth.

If they could do that, our winemakers asked, then why can't we grow grapes?

Many of South Dakota's winery owners, and much of the population at large, come from a winemaking tradition. Wine didn't start here with the first commercial vineyard in the mid-1990s. It started with baskets of fragrant wild plums; tart rhubarb; sweet, sunny dandelions; and whatever else early European settlers could gather from their adopted home. Long before there was local wine on any store shelf, bottles and barrels and jugs lined the root cellars of Dakota Territory, full of that fermenting flora.

While working on this book, it has been our privilege to travel to many of South Dakota's wineries. Tasting the grapes and reveling in the variety of flavors encased beneath their delicate skins. Walking through acres of netted vines, accompanied by the music of clinging birds trying to pick at the berries protected beneath the deep-green leaves. Snipping the dense, ripe clusters from the vines as we each helped in the harvest. Visiting with winery owners and discovering what led them to take a leap of faith on an untested venture. While some came from agricultural backgrounds, their professions were as varied as South Dakota's landscape—chemists, mathematicians, lawyers, professors, civil servants, truckers, engineers, marketing pros, fitness instructors and college administrators, all of whom saw an opportunity and said "yes."

Being part of an industry in its infancy has both advantages and drawbacks, though. Because many of the grapes grown in South Dakota are cold-hardy varieties developed in the past half century, largely at the University of Minnesota—and, to a lesser extent, at South Dakota State University—these varieties are still emerging. Research continues in an effort to make grapes like Valiant, La Crescent and Frontenac better. That means the wines we were tasting two decades ago may have been less refined than those we sip with dinner today, despite the winemaking process being quite the same. In many cases, though, the wine has gotten better because the winemakers themselves have evolved from hobbyists with day jobs to professionals focused on creating a quality product. And working with grape varieties that are merely decades old allows for freedom that makers of the old standby wines will never enjoy.

In these pages, it is our aim to deliver as vivid a picture as possible of South Dakota's burgeoning wine industry, where it began and where it is headed. One great advantage of writing a history such as this is most of the founders are alive and accessible. They are still hands-on, developing new products and fine-tuning old. Many have taken time to sit down and share

their successes and failures, unearth photographs and newspaper clippings, dig up old recipes and do everything in their power to make sure we had all we needed to show the world that South Dakota *is* wine country.

We hope that our gratitude to these people, and our pride in this beautiful state, is expressed clearly through the telling of their stories in the spirit we intend—with warmth, love and appreciation for the industriousness they and their ancestors displayed when deciding to take the fruits of this prairie and turn them into wine.

—Denise DePaolo

WINE ON THE PRAIRIE

Anna and her husband, Jon, looked out the window of their simple sod house. The rolling plains of grass were a vast expanse in front of them. The hills gently ebbed and flowed until they disappeared on the horizon. It was a horizon that in many ways seemed similar to the Vojtas' home in Moravia, Czechoslovakia. Yet it was so, so very different.

Fearful of the war that was nearing their homeland, Anna Pesä and Jon Vojta saw no other option than to flee their country. They were anxious for their freedom and their way of life. They had heard what America had to offer. It was a promised land for those who could get there. Land was available. Farming was a viable option. The United States really was a place where Anna and Jon believed they could raise their family safely and securely—if they were willing to work hard.

The couple saved what money they could and sold any possessions they could to secure passage on a vessel to the United States. They arrived in the country in 1876, as America was celebrating its 100th birthday. The Vojtas arrived on the East Coast with what few possessions they had left.

Eventually, Anna and Jon made their way to the Dakota Territory, a land with great farming opportunities but also severe winter weather. The cold was not a hindrance for the couple, and they soon homesteaded in what is now very northern South Dakota—almost on the North Dakota border—in Mound City, Campbell County, near present-day Mobridge. This spot was chosen over others because Jon saw it as less congested than areas like Tabor, another popular homesteading spot. In April 1891,

the couple settled and started construction on their home—a sod house, common for homesteaders in the American Midwest.

Hard Work

There were definitely hardships to this life. One was the language barrier Anna and Jon faced. They took it upon themselves to learn English as quickly as possible and then to teach the language to their children. This was an important priority. Additional areas of their new lives were also difficult, but they had settled in a community filled with immigrants, many others from Czechoslovakia, as well. The families often helped one another through trying times, no matter the situation.

Of course, living in a sod house was not luxurious. Ralph Vojta, Anna and Jon's great-grandson, knew this was not easy for his ancestors. He had never heard any story of how "nice" and "comfortable" living in the sod house was. Instead, he always caught the phrase, "It was home," commented quite fondly. "I never heard the original family complain [about] any hardship they ever encountered. They were tough, determined people. They had to be."

Anna Pesä made wine in the old country, Moravia, before making the move to the United States. The region had a very strong winemaking tradition then; it still does. Moravia is in today's Czech Republic, on the border of modern-day Slovakia. Then, Anna and other traditional winemakers would have made wines from the indigenous grapes of that part of Europe, grapes like Muller-Thurgau and Blaufränkisch. All production was done by hand, from the planting, the pruning and the picking of the grapes to the stomping, the pressing, the fermenting and the bottling of the wines.

Earthenware containers, basically jugs with stoppers, were used for multiple processes of making and serving the wine. Only native yeasts were used to start fermentation. These yeasts were found naturally on the grapes themselves. Once the grapes were picked and crushed, the yeast would start fermentation automatically. These wines were then aged in handmade barrels inside hand-dug root cellars, all under the watchful eyes of home winemakers like Anna Pesä.

After arriving in America, Anna continued to make wine as she raised her family. Her son, Thomas, would often help her with the work. Then Thomas met his future wife, Frances Kalda. Frances's mother, Josefa Kalda,

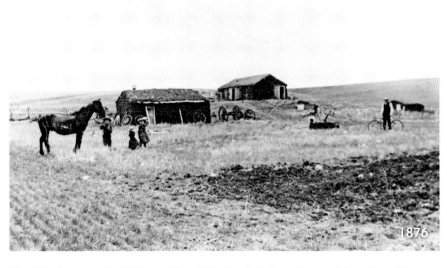

The Vojta homestead in 1876 near Mound City, South Dakota. *Courtesy of Prairie Berry Winery.*

also immigrated to the United States. Josefa was Bohemian, a "neighbor" to the Moravians in eastern Europe. Josefa brought with her an extensive winemaking background from her homeland. Frances had learned these winemaking traditions well before she married Thomas. After Thomas and Frances were married, the Vojtas and the Kaldas continued their connections to their native homes through wine.

It was through Thomas and Frances that winemaking was not lost but instead passed on to the next generation, and the next and the next. Thomas and Frances had five children in the sod home near Mound City. Frank was their son. Frank's son Ralph Vojta always loved making wine with Grandma Frances. Ralph remembered that Frances, with winemaking in her blood from both sides of her heritage, would have him and his brothers pick wild berries each autumn from all over the prairie surrounding her home. This harvest provided the berries that would go to the hillside cellar for "production."

Frances made jams and jellies as well as wine. Ralph recalled, "Whatever she did was delicious. I well remember the taste of the jellies on homemade bread and the special taste of chokecherry wine served on special occasions." Ralph remembered on holidays such as Thanksgiving

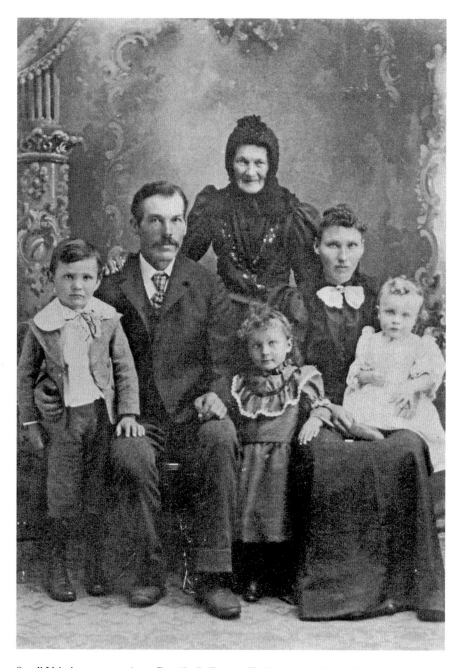

Sandi Vojta's ancestors: Anna Pesä (*back*), Frances Kalda (*seated right*) and Thomas Vojta (*seated left*), with their children. *Courtesy of Prairie Berry Winery.*

and Christmas that he was allowed to have one tumbler full of wine served with his meal. It was a special, Czech crystal glass. "Ah, the memory," he noted with fondness.

Anna and Frances used their own South Dakota fermentation techniques, which were passed on to Ralph through those fall harvests. The ladies used whatever was available, for both fruit and equipment. Ralph's great-grandfather Jon made wood barrels for aging the wines. Jon often sourced these trees from near the Missouri River. The berries for the process changed frequently, depending on what was available to pick that year or even that month.

Ralph Vojta, Sandi's dad, as a child. *Courtesy of Prairie Berry Winery.*

Ralph's father, Frank, was usually the production assistant, helping his mother with wine production but never actually making the wine himself. Then Ralph became the assistant. After Grandma Frances's passing, and as Ralph aged and matured, his curiosity for making wine also grew. He wanted to do it himself, but he had to do this from memory. Frances had not written down a process. She had never used a recipe, so to speak. She just used what she had and made each "vintage" work. Since Ralph had no written instructions, he began a process of trial and error that would take him years to perfect. However, after much experimentation, Ralph finally got a chokecherry wine that he thought was worthy of his grandmother.

A LABOR OF LOVE

Making wine like his grandmothers made was truly a labor of love for Ralph, a way to keep connected to his family and his heritage. This was a labor that he instinctively passed on to his daughter Sandi, the fifth generation of Vojtas to make wine in South Dakota. She affectionately stated, "I grew up with fermentation. It was part of my life. I experimented with the properties of yeast fermentation when I was a kid."

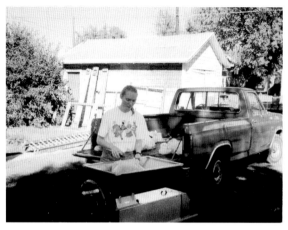 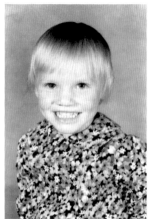

Left: Sandi Vojta working an early crush at the Vojta home in Mobridge. *Courtesy of Prairie Berry Winery.*

Right: Sandi Vojta as a child. *Courtesy of Prairie Berry Winery.*

Sandi was intrigued with how yeast fermentation worked. Even at the tender age of four, she used her mother's bread yeast to test what yeast did. As she grew up, she joined her dad in his winemaking tests. By kindergarten, Sandi was actively helping Ralph make wine. "My dad and I picked berries together. We fermented wine together, and this started when I was five years old. I would pick prairie berries into my ice cream bucket that my dad tied to my waist with twine, then bring them home to our basement, process them and start the fermentation." Like her father, Sandi was allowed to drink this wine at special occasions and holidays. The passion for making wine was officially handed to the next generation.

Sandi continued to ferment at home with her dad, and she continued her studies in her formal education at South Dakota State University. She studied fermentation while earning a bachelor's degree in biology from SDSU. As part of her coursework, she collaborated with and learned from other winemakers. Following in Ralph's footsteps, she honed her wine skills with every fermentation. However, Sandi was moving toward more formal goals than just keeping a family tradition alive, although this was a huge part of Sandi and Ralph's next endeavor.

Their at-home winemaking had progressed to such a level that when Ralph and Sandi did share their beverages with others, the drinks were thoroughly enjoyed. The Vojtas' wine was appreciated so much that others wanted to buy the berry wines from the prairie. Sandi wanted to provide

something unique to the state with these wines from her family heritage. She wanted a truly "South Dakota experience." Sandi and Ralph were working on an idea to share their family winemaking with others…many others.

TO BRICKS AND MORTAR

Sandi's work toward her family's wine heritage and her goal to improve her fermentation abilities "never stopped." After the Farm Winery Bill passed the state legislature of South Dakota in 1996, Sandi and Ralph decided they would continue to make wine and find more ways to share it with others. In 1998, the Vojtas worked toward establishing a winery, the second in the state. Sandi—always proud of her family legacy—stated, "It is now called Prairie Berry Winery…the rest is history."

Their first vintage was 1999. In Ralph's basement in Mobridge—in the same county as the original Vojta homestead—the two made Razzy Apple, a fruit wine that blended raspberries (berries of the prairie) and apples. It was a semisweet wine and was first sold in 2000. In far northern South Dakota,

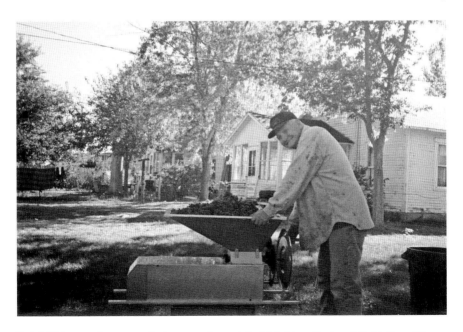

Ralph Vojta pressing grapes during an early crush in Mobridge. *Courtesy of Prairie Berry Winery.*

Ralph and Sandi Vojta during an early bottling in the basement of the Vojta home in Mobridge. *Courtesy of Prairie Berry Winery.*

Mobridge was a wonderful community to homestead and to live; however, it was also incredibly remote, far away from the populated areas of the state that draw heavy tourist traffic throughout the year. Thinking of how to best spread the South Dakota experience to the most people, Sandi and Ralph moved their winery to Rapid City, south on Highway 79. From this location, the Vojtas sold their Prairie Berry wine direct to consumers and via retailers all over the state of South Dakota.

At this point, Matt Keck (Sandi's husband), Sandi and Ralph were the entire Prairie Berry Winery staff. They found and sourced the fruit for wines all over the state. They harvested the fruit in the fall. Only the three of them made the wine—from fermentation to aging to bottling. And it was only the three of them who worked in the tasting room to sell the wine. They were literally a three-person business, showing that they made do with what they had, just like Anna and Frances did nearly ninety years before.

"Each generation did the best they could. Even when we commercially started, we did the best we could with what we had. We started from nothing, utilizing plastic containers we could afford for fermentation. We did everything by hand as our ancestors did until not that long ago," said Sandi.

Building this family business was, at times, grueling work. Once profits were made, most of these went right back into the business; the sole purpose was to build the dream of sharing South Dakota wine.

Growth

Growth to build this dream was always on Sandi's mind. The first step to this development was a brick-and-mortar winery and tasting room. Sandi, Matt and Ralph found the perfect spot on Highway 16 east of Hill City, just near the intersection at Three Forks. The picturesque spot was surrounded by natural beauty, with a view of Harney Peak in the distance. Tourist traffic freely flowed by this serene location, and there was room surrounding the site for possible development in the future. Construction began, and by the summer of 2004, Prairie Berry Winery had a lovely home with an on-site production facility and stunning tasting room.

In the design of the winery, Sandi used her favorite inspiration: her home state of South Dakota. The building was a fusion of the farming found on the Dakota prairie and the mining found in the Black Hills. Sandi wanted the structure to "blend into the hill-scape," in a sense, as if it had always been there—she wanted it to feel as if it belonged. "Traditional buildings for both farming and mining are purely utilitarian, both in material choice, as well as in the additive qualities." With this in mind, the "utilitarian" structure of the production area matched the striking façade, all while appearing to have been a part of the farming and mining industries. The design fit perfectly in the beauty and history of the region. Sandi achieved her goal.

Sandi, Ralph and Matt also used green building principles during construction. "How did Great-Grandma Anna Pesä build her homestead in South Dakota? They utilized common sense 'design': reduced the amount of materials used, recycled and reused materials that were available and utilized local materials. Anna Pesä practiced sustainable design out of necessity; a prairie homestead is the perfect representation of a green building." With this in mind, the Vojtas kept sustainable values in all parts of the structure and its processes. Prairie Berry became environmentally responsible with building materials and resource management. From local stone to electrical efficiency or from reclaimed wood to water conservation, many of the same practices homesteaders used one hundred years ago were reflected during construction. Large amounts of recycled and recyclable

Construction of Prairie Berry Winery outside Hill City. *Courtesy of Prairie Berry Winery.*

supplies were utilized. Geothermal heating and cooling were used. The site was landscaped with native plants and greenery that were drought resistant. No detail was too small to reflect the original Vojta homesteading philosophy.

It wasn't long after this initial construction that Sandi realized the growth for which she was hoping was indeed happening. In a mere two years, more space was already needed. An events space was added to the tasting room. This addition was worked into the original design with ease. Sandi always knew "the growth of Prairie Berry Winery would need to occur in phases, yet we desired a finished look for each individual phase." She saw the building as a collage on which additions could be continually made. The new events space added to the organic feeling of the inventive structure and, once again, seemed to feel as if it was part of the building from the start.

The fast-growing business was fueled by the truly South Dakota products and experiences Prairie Berry Winery was providing for its guests. The pioneer spirit was definitely shown in wines like the ever-popular Red Ass Rhubarb, fall-favorite Pumpkin Bog and prairie-inspired Buffaloberry Fusion. Each wine that Sandi fermented had a story and was a part of her family heritage or had a part in her state's history.

Great-Grandma's Chokecherry Wine was an obvious honor to some of the berries Grandmas Anna and Frances would have found on the prairie of the Dakota Territory. Gold Digger and Heritage are both pear wines, originally made because some friends had so many pears growing in their backyard—the clear solution was to have Sandi and Ralph pick the fruit for wine. The local fruit became the sweet pear wine Gold Digger (the obvious reference to mining life in the Hills) and the dry pear wine Heritage (a direct allusion to Sandi's family's lineage). Lawrence Elk, a wine from South Dakota black currants, featured a large buck on the label with men's undergarments stuck in his antlers. The inspiration for this label art came from a story Ralph told of looking out his window to see such a deer with the clothes Ralph had left on the clothesline. Every wine has a story, a history, a legacy.

Prairie Berry's top-selling wine is Red Ass Rhubarb, the wine with the friendly donkey on the label, which has become the unofficial logo of the winery. This also happens to be the most award-winning wine Sandi has produced, winning 107 separate awards at last count. These include such prestigious awards as Gold at the San Francisco International Wine Competition (2005), Best of Class at the Indy International Wine Competition (2010), Best of Class and Judge's Choice at the San Francisco Chronicle Wine Competition (2010) and Double Gold at the International Eastern Wine Competition (2012). The second-most award-winning Prairie Berry

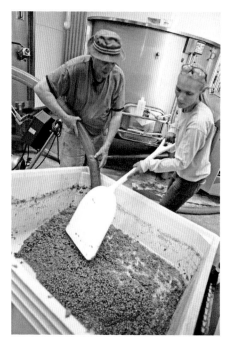

Ralph and Sandi Vojta working crush.
Courtesy of Prairie Berry Winery.

wine goes to Calamity Jane with 72 awards, such as winning Double Gold at the Finger Lakes International Wine Competition in 2011. Next is Lawrence Elk with 66 medals, including Best of Class in 2012 from the New World International Wine Competition. As of 2016, Prairie Berry wines have won a total of 944 awards and counting. Customers agree with the wine judges across the country—the most popular wines Sandi produces after Red Ass Rhubarb are Lawrence Elk and Calamity Jane.

The popularity of these distinctive Black Hills wines spurred the need for more development, just what Sandi, Matt and Ralph had been working toward. Since more space had already been added for the increasing number of loyal guests Prairie Berry was serving, now more wine needed to be made, too! In 2009, the first increase to the production space took place. The expansion more than doubled the production capabilities of wine at the location. Specialty tanks were installed in the enlarged manufacturing area; each tank could hold 10,500 gallons of wine. This was followed closely by another production expansion in 2011.

Much like the seasons passing on the prairie, a cycle was also happening at Prairie Berry Winery. Great wine was made. Customers enjoyed the product. More room was made for the guests, so more guests came. That meant more wine needed to be produced, and even more people appreciated Prairie Berry wines. These expansions in production and space created some other needs for the business. In 2012, Sandi and Matt acquired land from the U.S. Forest Service in a land swap. This expansion wasn't for more production area or event space; rather, it was for much-needed parking and outdoor amenities, like landscaping. That same year, the tasting room and event space was remodeled to provide for better use of the existing space. Instead of just one tasting counter, a second was added to keep up with the summertime

flow of traffic. The bathrooms also received a necessary renovation. At the same time, a face-lift was given to the building. The façade was updated with even more native stone that kept the farming and mining inspirations evident in the building.

In all these expansions, Sandi stayed true to the mission that had been her focus since she was four years old: fermentation. She continued making award-winning South Dakota wines, but her curious spirit when it came to fermentation never left. If anything, making wine only made this inquisitive essence increase. Her next step was clear: Sandi wanted to also make beer.

MORE THAN JUST WINE

The next member of Sandi's Prairie Berry family, Miner Brewing Company, opened just next door to the winery. As luck would have it, the building adjacent to the current tasting room became available and was remodeled. Many of the same inspirations were used in renovating the building for the brewery. One step inside showed the history of the mining lifestyle of the Black Hills. Again, local products were accessed and sustainable principles used, and Miner Brewing officially opened in 2013. Soon after, an outdoor patio and an enclosed patio were both added, creating three-season seating for craft beverage lovers.

Although Sandi was making beer, her wine heritage was always close at hand. Her craft beers had unique twists, often using fruit in the recipes. For instance, her Mango Cream Ale was a customer favorite. Sandi also used her favorite berries of the prairie, such as chokecherries and elderberries, and even some of her favorites for wine, like pumpkin and crabapples.

Prairie Berry Winery became known as a destination for locals and tourists alike. The world-class chefs and kitchen offerings were among the many draws, as were the different events for which the winery also became very popular. The annual Fezziwig Christmas Festival was a favorite. Other favorites were the Pink Slip Ball, Mother's Day brunch and summertime bistro dinners. These special occasions actually became difficult to manage because the winery was so busy all year long that even the expanded spaces were not big enough anymore.

At this same time, the Mistletoe Ranch—a year-round Christmas shop next door—came up for sale. The Vojtas purchased the house and the surrounding land, and renovations began to continue another "extension of

the unique South Dakota experience" in The Homestead, a space to hold special events. This gave the staff the ability to continue the events of which the winery had long been so proud. Except now this could be done without interfering with any of the day-to-day tastings and meals at the winery itself.

Of course, Sandi thought very deeply about how to incorporate the design of The Homestead at Prairie Berry Winery into the existing design of the rest of the facilities. The original, two-story portion of the house that was Mistletoe Ranch had its own history. It was a home that was moved from the town of Pactola before Pactola was covered with water to form Pactola Lake. This historical reference was important to Sandi; she wanted to keep parts of the original design. She also wanted to make this special space reminiscent of the dance halls of small communities generations ago, perhaps the kind where Anna or Frances attended dances. Local construction company GBA, out of Rapid City, completed the construction of the space. Then Sandi gave it the official name of The Homestead at Prairie Berry Winery, yet another nod to the Vojta family homestead all those years ago.

The "new" area held up to 150 people inside, 50 on the covered porch and 50 in the outdoor tent. There was also a large dance floor, reception space and a serving bar. In addition, a full commercial kitchen made serving

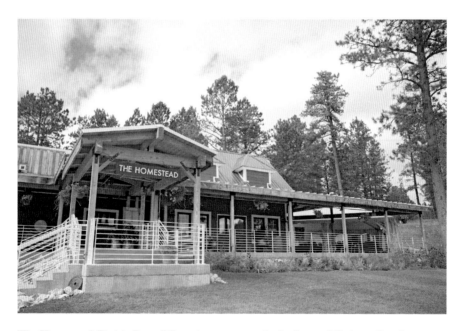

The Homestead, Prairie Berry Winery's event venue in the former Mistletoe Ranch building, which was originally a house in Pactola. *Courtesy of Prairie Berry Winery.*

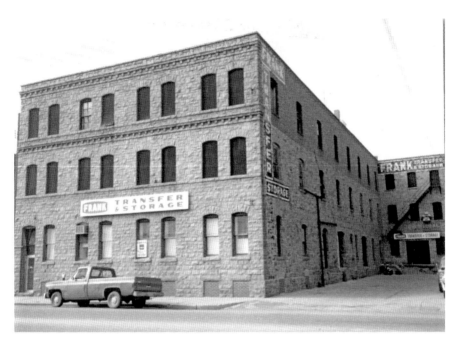

The Frank Transfer Storage building, the historic building that now houses Prairie Berry East Bank in Sioux Falls. *Courtesy of Prairie Berry Winery.*

full meals at The Homestead's parties possible without affecting any other services at the winery. When not in use for events, this kitchen can be utilized to make Prairie Berry Made products—the jellies, jams and compotes reminiscent of the other items Anna Pesä and Frances made from the berries of the prairie.

The inaugural event at The Homestead in 2014 was a fiftieth wedding anniversary party for two of Prairie Berry's wine club members. Five weddings were held the first summer The Homestead was open. Since then, many more events have taken place there, including numerous weddings. One of the most unique and moving events held there was an air force retirement ceremony. The fact that patrons choose the winery for such special occasions is very humbling, and Sandi and staff members work very hard to make every detail impeccable. Prairie Berry sees it as a true honor to be a part of such extraordinary Black Hills occasions.

Expansion continued for Sandi, Matt and Ralph, and not just at the Hill City location. In order to pay respects to all the Vojta family South Dakota roots, a presence was necessary other than just on the western side

of the state. To rectify this, Prairie Berry East Bank was opened in Sioux Falls, the largest city in the state, in 2014. There was a full tasting room for Prairie Berry wine and Miner Brewing beer at the Fermentation Bar, and the Epicurean Bar was opened, featuring selections of regional cheese and charcuterie to pair with the beverages. Many wine club members live East River, so it made perfect sense for Prairie Berry to offer respite at the East Bank members-only lounge.

The Sioux Falls location, housed in a historic building in bustling downtown, fits well with the heritage for which Sandi, Matt and Ralph always strove. The artistic space was renovated by Sioux Falls architecture firm Koch Hazard. The firm was recently awarded the 2016 Design Award for this project from the American Institute of Architects of South Dakota. This honor went to only two of the twenty-seven submissions received that year. The design blends the old and the new, the modern and traditional, just like Prairie Berry itself.

A FINAL HONOR

All of these literal new additions helped spread the unique experience that is Prairie Berry Winery. But Sandi still wanted to take yet another step to honor her great-great-grandmother who started it all: Anna Pesä Vojta. In order to truly do this, it had to be done through fermentation, so Sandi started a second wine label, aptly titled Anna Pesä. These wines used the traditional winemaking grapes and processes that Anna would have used, all with the specific goal of having a similar taste profile to what Anna would have made back in Moravia before coming to the United States.

Anna Pesä would have used traditional European grapes like Riesling, Chardonnay, Chenin Blanc and Cabernet Sauvignon. Sandi used these grapes, too, for her Anna Pesä wines. She could not source these from South Dakota because the weather in the state does not allow these grapes to grow. She sourced her Anna Pesä grapes from the West Coast, where traditional *Vitis vinifera* grapes grow. These grapes came to her Hill City, South Dakota production area in large bins immediately after harvest. Although it was a long trip to Prairie Berry, Sandi would have it no other way to use grapes from another source. Her ultimate goal was to work with growers to choose fruit to express the specific style of wine for which Sandi was looking—a style she believed her ancestors would appreciate.

After delivery of the fresh fruit, every step of crush, fermentation, aging and bottling happened in the shadow of Mount Rushmore. These grapes were given extra, extra special treatment during the entire process. They were handled and fermented in smaller lots. Then the two, three or four smaller batches were blended to achieve the style of complexity to fulfill not only Sandi's vision but also a vision passed down from Anna to Frances and on through the generations. The wines received old-fashioned treatments even after fermentation: battonage, or stirring of the lees (dead yeast cells) into the wine; delestage, or racking the wine from one vessel to another; and punching down, or stirring the cap of seeds, stems and skins back into the wine.

The newest—and perhaps most meaningful—Anna Pesä wine Sandi produced was the Blaufrankisch, a traditional red wine grape grown extensively in Austria, Hungary and the Czech Republic. Sandi wanted to make this style of wine from this grape since the very first vintage of Anna Pesä wines. However, it took some time to find a proper source for the fruit that met Sandi's standards. Once she did, she set about making a quality wine from the Moravian grape, aiming for such excellence that even those who may have never heard of Blaufrankisch would still try the spicy, medium-bodied wine.

Sandi has paid tribute to her family with every step she has taken since 1998, and even before. Sip after sip, the traditional European and Dakotan influences have been infused into every Prairie Berry product. As the fifth generation to make wine, she honored her ancestry, her dad and her grandfather. But especially, she honored her great-grandmothers, Frances and Anna, strong women who made the best of their prairie lifestyles, made the most of their simple sod homes and made the most of their views of the rolling hills. Yet, most of all, they made the most of the berries on the prairie.

EARLY DAKOTA EXPLORERS, SETTLERS AND WINEMAKERS

A LAND FOR EXPLORATION

For roughly the first ninety years of the United States' existence, the land that would become South Dakota was widely regarded as a vast, wild place. Dakota Territory, which existed from 1861 to 1889, included present-day South Dakota, North Dakota, Montana and Wyoming. It was considered "Indian Territory" before the U.S. government opened it up to settlement, a process that slowly, systematically took land from indigenous Americans until they were confined to reservations composed of the region's least hospitable tracts.

In 1870, 40,501 residents of Dakota Territory were counted in the U.S. Census. That number would soon explode due to several factors. Among them was the Dakota Southern Railroad, which opened the community of Vermillion to general traffic in 1872, and in the mid-1870s came the "Great Dakota Boom," fueled by free land and mining opportunities. By 1880, 135,000 people lived in Dakota Territory, and by 1885, it was 450,000.

Part of the 1803 Louisiana Purchase, the area that is now Fort Pierre in the state's center, was claimed for France by the Verendrye brothers, who buried a lead plate there in 1743. Like Lewis and Clark sixty years later, they were seeking a water route to the Pacific Ocean. The plate they buried was discovered by local teenagers in 1913 and is now in Pierre's Cultural Heritage Museum.

For the first two centuries that Europeans occupied the North American continent, fur traders of predominantly French descent made up the majority of white visitors to the area. Their encounters with local Native Americans were largely peaceful, as the traders rarely lingered in any one area for too long, sometimes married into the tribes and brought items to trade. These items included guns, knives and spirituous drink.

By the time the Corps of Discovery, better known as the Lewis and Clark Expedition, arrived in the Great Plains, the tribes were familiar with alcoholic beverages, but as they tended to be mobile societies that followed herds of buffalo, they had no independent tradition of fermenting or distilling. For the indigenous peoples of the southwest United States and Mexico, who tended to build more agricultural, stationary societies, it was a different story. Much like the European settlers with their home winemaking traditions, cultures like the Mayans had "balche," which was a wine made from honey and bark. There was no evidence that the Sioux, which was the dominant Native American group on the Northern Plains by the late 1700s, previously had a similar beverage for recreational use.

When Lewis and Clark explored what would become South Dakota in 1804 and 1806, they found *Vitis riparia* (wild grapes) growing along the banks of the Missouri River, noting the discovery in their journals. Although the high acidity of *Vitis riparia* makes them imperfect wine grapes on their own, the vines provided inspiration to many pioneers of South Dakota's modern wine industry. Dr. Ronald Peterson, the South Dakota State University biologist who developed the Valiant grape, believed that if grapes grew for centuries in such a harsh climate, then they could serve as a basis for the development of cold-hardy wine grapes.

In 1804, Lewis and Clark camped along the Missouri River, where the town of Vermillion now stands in the southeast corner of South Dakota. Today, Eldon and Sherry Nygaard, owners of Valiant Vineyards, pick wild grapes from the same vines, some of which grow on their Vermillion property. From these and others collected throughout the state, they make a Wild Grape wine, which retails for about fifty dollars per bottle. In a January 17, 2005 article in the *Sioux City Journal*, Nygaard said that on September 26, 1804, the expedition "returned from their hike to the now famous Spirit Mound and camped less than 200 yards from what is now the winery."

To commemorate the Lewis and Clark Expedition's 200th anniversary and the winery's historic connection, Valiant released a series of three wines with the cooperation of the Lewis and Clark Bicentennial Council. The first of these was released in 2003. Called the "Ameritage" collection, the three

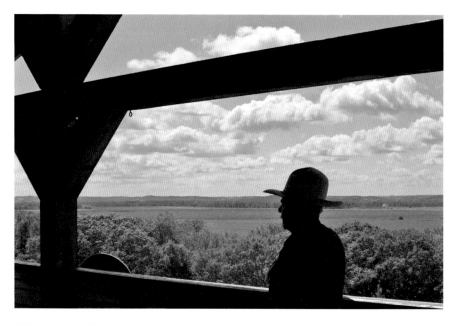

Valiant Vineyards owner Eldon Nygaard looks out on the Missouri River Valley from the winery. *Courtesy of Denise DePaolo.*

bottles were sold separately and as a boxed set with a high-quality cork, meant to store well for upward of twenty years. Each wine was blended with *Vitis riparia* and grapes from across the United States. The first, 2003's Thomas Jefferson, featured grapes from vineyards in the eastern United States, and the subsequent two bottles, 2004's Captain Clark and 2005's Captain Lewis, had the wild grapes blended with grapes representing progressively westward vineyards, patterned after the journey of Lewis and Clark.

From Fur to Farms

Until the mid-1850s, the fur trade was the dominant industry for Europeans in the Dakota Territory, changing in emphasis from beaver pelts to buffalo hides as beaver became over-trapped and demand decreased. Due to the transient nature of the lifestyle, wild fruits and vegetables were gathered by traders, but few garden crops were raised. As starvation was a grim possibility for many, most of the wild food collected was consumed rather than fermented.

Like most of the supplies traded for hides, whiskey and a powerful alcohol called "high wine" or "Indian rum" was shipped by canoe and steamboat to Missouri River trading posts like the American Fur Company's Fort Pierre Chouteau from St. Louis as mountains of pelts were shipped out. High wine was made from combinations of brandy, sherry, rum and spices like cinnamon and nutmeg and then often diluted for trade or consumption.

In 1855, Fort Pierre Chouteau was sold to the U.S. Army, ending much of the trade in the upper Missouri River area. Downriver, another military installation, Fort Randall, was established the same year. In 1857, the first permanent white settlements were established in what would officially come to be called Dakota Territory four years later. With these and subsequent waves of homesteaders, European-influenced domesticity and agriculture arrived, and so did home winemaking.

Mid-nineteenth-century crop failures, overpopulation and lack of land for new farms in their home countries compelled thousands of Norwegian, Swedish and Danish families to seek opportunities in the United States. In 1859, the first Norwegians settled in Clay County, South Dakota, establishing the area's first farms. Upon its founding eighteen years later, Vermillion would be the county seat. Danish settlers brought their "cherry kijafa" to the area and began making similar fortified wines from local fruit.

The 1862 Homestead Act proved enticing for many Europeans who dreamed of tilling their own soil. It guaranteed free land to those who would develop it for five years. Many pioneers came overland in covered wagons, while others took the train to St. Joseph, Missouri, and then traveled by steamboat up the Missouri River. By 1866, Dakota Territory's total white population would grow from a handful to 5,000. Between 1825 and 1925, more than 2 million Danes, Swedes and Norwegians would immigrate to America, many settling in the Midwest.

A blight caused by the phylloxera aphid wiped out much of the French wine industry in 1863. Vines growing in the eastern United States were found resistant to the disease and were planted in the hardest-hit regions of France. These hybrids would lead to the production of many new varieties of wine, including those developed from breeding with the cold-hardy *Vitis riparia* at SDSU and the University of Minnesota in the late twentieth century.

In 1868, the Fort Laramie Treaty was signed, which ensured Sioux tribes lands west of the Missouri River, including the Black Hills. That same year, the Czech Agricultural Society was formed in Chicago with the purpose of establishing communities in the West. This group settled in Bon Homme County, on the eastern bank of the Missouri, and helped found

the town of Tabor, roughly twenty miles west of the territorial capital Yankton. Another Czech settlement was established around Springfield in Bon Homme County in 1869.

A PRAIRIE SANCTUARY

The 1848 Revolutions prodded the largest influx of German immigrants of the 6 million who would ultimately come to America between 1820 and World War I. In 1850, one of those immigrants was Christen Gossman of Mecklenburg, Germany. Born in 1821, he came to the United States at age twenty-nine and became a farmer in Dakota Territory. Along with him came the grape crusher and destemmer that he and his wife, Sophie, used to carry on the family winemaking tradition. The Gossman family grape press was passed down to son Christen and then to grandson John Ernest, great-granddaughter Lavonne and great-great-grandson Eldon Nygaard, owner of South Dakota's first commercial winery, Valiant Vineyards. Although the wine industry is just two decades old in South Dakota, Eldon's son, Leif, is a sixth-generation American winemaker.

Eldon remembered his mother, Lavonne, using the heirloom press to make great-tasting mulberry wine from the trees on the family's Turner County farm. Her winemaking materials included quart-sized Ball jars and one-gallon glass jugs. Stoneware crocks covered in cheesecloth were used during the fermenting process. The thin cloth cover helped to keep out flies and other pests.

Many of the German immigrants who would come to settle in Dakota Territory were German Russians, known as "Volga Germans," who had lived for generations close to Russia's Volga River, near the Crimea. This group had been invited to settle in the region and promised religious autonomy, as well as freedom from military service, by a proclamation of Catherine the Great in 1762. In return, the Germans brought innovations to local agriculture. A century later, however, the special status of Russia's ethnic German population sharply eroded, and by 1874, conscription became law, as it was for other Russian men.

Required military service proved problematic for swaths of the population who had maintained their German customs and language and didn't consider themselves Russian. It was a particular conflict for Mennonites and Hutterites, whose religious practices required absolute pacifism. Both were

Left: Eldon Nygaard holds the heirloom press his pioneer relatives brought from Germany. *Courtesy of Valiant Vineyards.*

Below: Late nineteenth-century wheat harvest on the Oleson farm near Brookings. *Courtesy of the Library of Congress.*

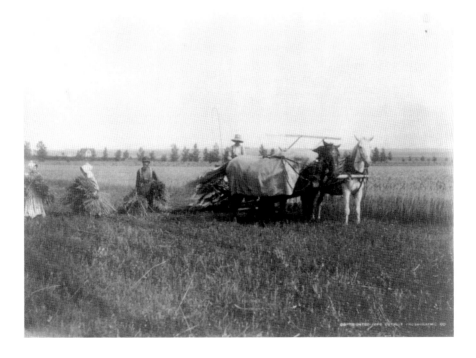

Christian sects of the Anabaptist movement, which opposed infant baptism, believing a baptism valid only in those who consciously choose it.

As a result of the growing restrictions on their freedoms and troubling religious conflicts, many German Russians chose to leave for America. By 1900, nearly 100,000 German Russians immigrated to the United States, and most chose to settle in the Dakotas, Kansas and Nebraska. The first Hutterites arrived in Dakota Territory in 1873 and began establishing self-sustaining colonies. As of 2016, South Dakota was home to 52 of the 134 Hutterite colonies in the United States. These agriculture-based societies are among the most important growers of produce for South Dakota's commercial winemakers.

WESTWARD TO STATEHOOD

Although illegal, white settlement was not confined to the eastern portion of Dakota Territory. By the mid-1870s, miners in search of gold were present throughout the Black Hills. This was prompted by an 1874 expedition led by General George Armstrong Custer that confirmed the existence of the valuable mineral.

In 1875, General George Crook ordered a group to leave the Custer area in the southern Black Hills by August 15 or they would be forcibly removed for trespassing on Indian lands. However, gold was discovered at Pactola on July 4. On August 10, the white miners officially organized the town of Custer, electing twelve aldermen, drawing town lots and establishing a saloon as the first business. True to his word, though, Crook and his men removed the would-be settlers on the fifteenth.

Recognizing the futility of policing the Black Hills against the desire for gold, the U.S. government set up a meeting with Sioux chiefs near the Red Cloud Agency in September 1875. The chiefs refused to cede the land, and the meeting ended in a near shootout and led to heightened tensions between the groups. The Black Hills War of 1876 was the result.

In November 1875, the last group of miners and settlers was escorted by the military out of the Black Hills, while simultaneously the first mining claims were established in Deadwood Gulch. One month later, the U.S. military withdrew its troops. As 1875 drew to a close, so did any official resistance to white settlement in the Black Hills. Within a year, gold production there would amount to $1.5 million.

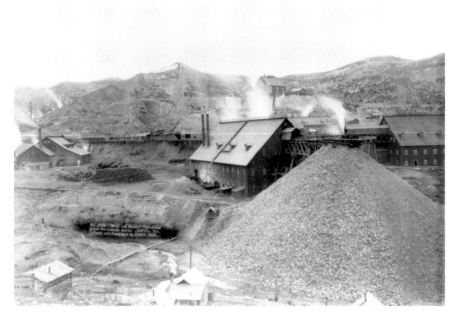

Part of the Homestake mining works in Lead. *Courtesy of the Library of Congress.*

Settlers of Dutch origin began establishing homesteads in southeast South Dakota's Lincoln County in 1879 and had branched west into Charles Mix and Douglas Counties by 1881, with many coming across the border from northwest Iowa, which had been a significant hub for Dutch Americans since the early 1870s.

In 1889, South Dakota attained statehood on the same day as North Dakota. President Benjamin Harrison is said to have shuffled the papers on his desk before signing, so no one would know which state entered the Union first. Along with statehood came a geographical change for the base of government. After much debate, political maneuvering and, finally, a public vote in 1890, centrally located Pierre became the permanent capital for the newly formed state.

Chapter 3

WINERY NUMBER ONE

A Vintner in the Making

Eldon Nygaard did not expect to become a vintner. But as a farmer, lawyer, teacher and businessman, he turned out to be uniquely suited to the role of father of the Mount Rushmore State's wine industry.

Originally from Viborg, nestled in the heart of southeast South Dakota farm country, Nygaard grew up working with his hands. His mother, Lavonne Nygaard, was of German stock and made fruit wines at home, as he would later in life—first as a hobby and then for a living. She was not his only inspiration, though.

As a boy, Eldon would help bale hay on the neighboring farm, owned by Karl and Selma Stotz. Mrs. Stotz, who had emigrated from Germany in her youth, believed in eating meals at 10:00 a.m., noon and 2:00 p.m. Eldon recalled loving to work there because they got to eat so much. His older brothers, Ronnie and Lowell, also got to sip the Stotzes' homemade dandelion wine. Every once in a while, young Eldon would sneak sips of the sweet, straw-colored tonic, too.

Another influence on young Eldon was his great-uncle, Carl Nygaard. While staying with his family, Carl would regale the kids with stories of bootlegging during Prohibition. It didn't take long for Eldon to try some fermenting of his own. He remembered making his first mulberry wine as a fifth grader, while attending a one-room country school in Hooker School District 57. In high school, a chemistry teacher let him experiment with winemaking and then distilling it with a glass still.

The Nygaard family (Eldon, Leif, Jeanette and Sherry) in 1994 on their Turner County farm. *Courtesy of Valiant Vineyards.*

Nygaard's destiny as a vintner was put on hold when he left the farm for the U.S. Army in 1966 and served as a helicopter pilot in Vietnam. In May 1968, the twenty-one-year-old was hit in the arm by enemy shrapnel while flying troops. The injury grounded him for weeks. He would later receive the Purple Heart for his wound. Among other decorations for his service in Vietnam were two awards of the Distinguished Flying Cross.

After returning home, Nygaard earned a law degree at Milwaukee's Marquette University. He graduated in 1976 and began work as a professor at Arizona State University–Tempe. During the early 1980s, Nygaard also taught at Colorado University–Boulder and University of Wisconsin–Milwaukee before moving to Reno, Nevada. Alarmed at elevating crime rates, Eldon and his wife, Sherry, along with their children, Leif and Jeanette, moved to South Dakota in 1993. He began his final stint as a professor at the University of South Dakota School of Business in Vermillion, less than forty miles south of his native Viborg.

THE "HAVE YOUR OWN WINERY" BUG

Grape growing and winemaking once again piqued Nygaard's interest with the return to his home state. He and Sherry purchased a farm two and a half miles from Viborg that was previously owned by a great-uncle.

In an article titled "The Politics of Establishing South Dakota's First Winery," published in the June 30, 1997 American Vintners Association newsletter, Nygaard wrote that he and Sherry had caught the "have your own winery" bug from visiting wineries in other states and started making small batches of their own wine at home. "Friends and neighbors laughed at the then 'outrageous' notion of growing grapes for wine in South Dakota," he wrote. "Their doubts provided plenty of incentive to get us motivated."

The Nygaards' romantic idea looked like it might actually be possible when they learned about Dr. Ronald Peterson's work in developing the Valiant grape at South Dakota State University. The cold-hardy Valiant, which would later become the namesake of Nygaard's flagship winery in Vermillion, is the result of crossing Fredonia with *Vitis riparia*, wild grapes gathered from northwestern Montana.

As Peterson detailed in a videotaped, sit-down interview with fellow SDSU biologist Dr. Anne Fennell and Bob Weyrich of the South Dakota Department of Agriculture, Peterson spent years searching for wild grapes as far north and west as possible. These travels took him as far west as Montana and as far north as the Canadian border, where he found *Vitis riparia* growing along riverbanks. Surely, he believed, if these grapes could survive unmanaged in such climates, they could thrive under the care of South Dakota farmers.

Nygaard recalled that prior to the emergence of the Valiant grape, he knew of people growing some Concord grapes and other varieties that weren't really wine grapes. Valiant, he said, was a game changer. They were some of the first "wine grapes" that survived in South Dakota's harsh climate. "Not a perfect wine grape," he emphasized, but improved upon greatly over the years.

The Nygaards traveled to Brookings to gather more information about SDSU's viticulture program, résumé in hand. When Eldon and Sherry arrived, they asked who was in charge of winemaking and grape growing. They were told that there was no winemaking happening but were directed to Dr. Anne Fennell. The researcher had come to SDSU just a year prior and was working to resurrect the university's study of grapes—a focus that had largely fallen to the wayside since Peterson's retirement a few years earlier.

Fennell considers grapes to be a most fascinating plant. She began working at an orchard as a teenager in southwest Iowa and then went on to study plant stress physiology. She was interested in developing a program where she could "pull apart the trait of winter survival." Like Peterson before her, Fennell was interested in what made some grapes able to

Left: Valiant grapes at Schadé Vineyard and Winery. *Courtesy of Denise DePaolo.*

Below: Dr. Ronald Peterson's field journal, full of notes from his research into cold-hardy wild grapes. *Courtesy of Bob Weyrich.*

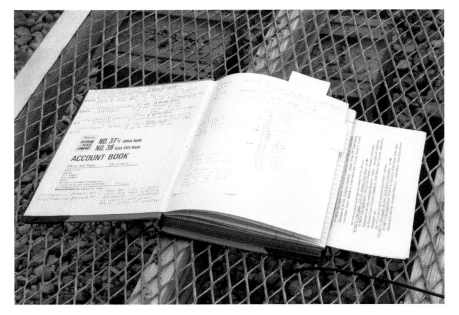

withstand extreme conditions. She was eager to see grapes grow successfully in the upper Midwest. Between South Dakota's Valiant grape and several cultivars developed by prolific Wisconsin viticulturalist Elmer Swenson (both independently and at the University of Minnesota), by the early 1990s the time seemed to have arrived.

Fennell, who had come to South Dakota from the University of Minnesota, had been looking for someone like Nygaard—someone with business experience, with an agriculture background and, most importantly, who had the follow-through to make the notion of commercial grape growing a reality. However, she cautioned Nygaard not to get in too deep too quickly. She recalled telling him that if he planted more than half an

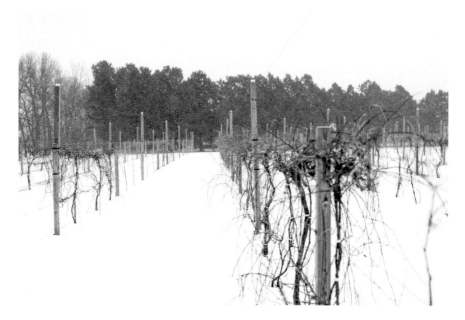

The test vineyard at South Dakota State University in winter. *Courtesy of Bob Weyrich.*

acre in the first year, she would not talk to him. But he was earnest in his interest to start a wine industry and set a full acre aside as a test site. They continued talking anyway.

As South Dakota had no industry and no one local to ask for advice, Fennell urged Nygaard to join the Minnesota Grape Growers Association, which had been established in 1975. The Minnesota state legislature had recognized the potential of a wine industry some years before and had allotted money to the University of Minnesota for research into cold-hardy grapes. That program grew significantly, yielding wine grapes like Frontenac, Frontenac Gris, Marquette, St. Croix and St. Pepin—developed, like the Valiant, by crossing French hybrid grapes with *Vitis riparia*. As a result, an industry of growers and vintners grew in Minnesota, which was producing up to five thousand bottles or $20,000 per acre annually by 1996. With the organization's guidance, Nygaard planted South Dakota's first commercial vineyard on his Viborg farm in 1993.

SEEDLINGS OF AN INDUSTRY

Nygaard remembered the planting of that first vineyard as a time of hopeful trepidation. The year 1993 was a very wet one. While farmers typically pray for rain, he was worried that his six hundred tiny grapevines, all wrapped up in a box, were doomed due to lack of sun and inhospitable soil. But he had no choice—they had to try. Still a faculty member in University of South Dakota's Political Science Department, Nygaard had ready access to a young workforce. He hired several students to come out to the farm, pull on overshoes and plant the fledgling grapes in mud up to their knees.

The gamble paid off big time. What Nygaard discovered was that it was an incredibly successful way to plant grapes. The excessive moisture meant that he didn't have to water the vines, and roughly 90 percent of the plants took. In that initial planting were six varieties of grapes in a one-acre test site. Many of the grapes were those engineered at the University of Minnesota, but the one that proved to be the most vigorous was the Valiant.

The Nygaards trained their vines on a carefully designed trellis system and adhered to a strict pruning plan, but it still takes at least three years of near-obsessive attention to determine whether a vineyard will be successful. It can

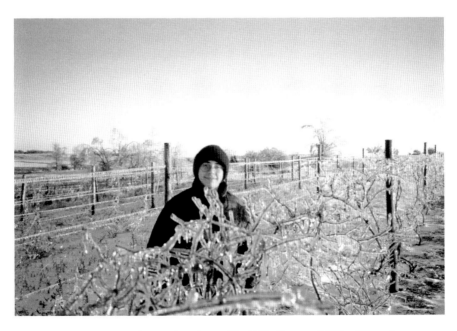

Leif Nygaard poses in his family's icy vineyard in 1995. *Courtesy of Valiant Vineyards.*

take seven years for it to produce high-quality fruit. By late 1995, though, the couple felt confident enough to take the next step toward commercial wine sales. However, as no wine industry existed in the state, no enabling legislation existed, either. As with so many other obstacles, it was up to the Nygaards to hack away at the brush obscuring their path.

MAKING LAWS, MAKING WINE

Eldon drew on his law expertise and drafted South Dakota Legislative Bill No. 0092, better known as the Farm Winery Bill, with the help of the American Vintners Association (now Wine America). Additional assistance came from Jim Schade. In the mid-1990s, Schade worked as a tax collector for the South Dakota Department of Revenue, a post he would retire from to avoid a conflict of interest when opening his own winery, Volga's Schadé Vineyard and Winery.

By definition, a farm winery is an operation that allows farms to produce and sell wine on site. South Dakota defines it as "any winery operated by the owner of a South Dakota farm and producing table, sparkling, or sacramental wines from grapes, grape juice, other fruit bases, or honey… with a majority of the ingredients grown or produced in South Dakota." The 1996 Farm Winery Bill required that 51 percent of the produce used to make wine be grown in South Dakota. It allowed for vintners to produce fifty thousand gallons of wine annually, which equals approximately twenty-one thousand cases.

South Dakota's largest liquor distributor opposed the bill, as it would allow wineries to sell at wholesale or retail, as well as produce wine. Those who testified in favor of the measure before state lawmakers argued that it would allow South Dakota to keep up with neighboring states, many of which had passed similar legislation. Minnesota, Iowa, Wisconsin, Michigan and Ohio all had farm winery bills patterned after New York's groundbreaking Farm Winery Act of 1976, which set the benchmark at fifty thousand gallons per year.

The other point proponents of South Dakota's bill made was the positive impact a wine industry would likely have on tourism and economic growth. A winery might mean a meal at a local restaurant. A few wineries in one area could mean a few meals, a night at a local hotel, souvenirs and gas. As agriculture and tourism are South Dakota's top two industries, lawmakers

were inclined to welcome a plan likely to bolster both, thus creating a new agritourism industry.

The bill easily passed through the state legislature and was signed by Governor Bill Janklow. Commercial winemaking became legal on July 1, 1996, making South Dakota the forty-eighth state with at least one winery. The Nygaards received South Dakota Farm Winery License Number One. Hill City's Prairie Berry Winery and Volga's Schadé Vineyard and Winery followed close behind, acquiring licenses two and three, respectively.

South Dakota native Jerry Lohr, founder of San Jose, California–based J. Lohr Winery, provided encouragement for the industry, as well. An alumnus of SDSU, Nygaard recalled that Lohr was excited to see a vineyard prosper in his home state and share some of his hard-earned expertise with the new vintners.

A VALIANT EFFORT

Later that summer, an army of friends, family and other community members showed up to help harvest at the Viborg farm. The volunteers, fueled by cheese, bread and a bit of wine, harvested 3,000 pounds of grapes from the vines. An additional 130 pounds of wild grapes were procured from the Rosebud Indian Reservation, and several hundred pounds of grapes were purchased from small growers in the southeast corner of South Dakota, in order to fulfill the goal of bottling five varieties. The Nygaards also recognized that relationships with growers from around the state served as insurance, in case hail, herbicides or frost damaged a particular crop.

In June 1997, Valiant Vineyards began selling its first run of four thousand bottles. The winery's initial offerings were the white table wine called Courage, a red table wine called Valor, a red wine known as Wild Grape, a raspberry wine and an elderberry wine. They also produced a seasonal apple-cinnamon wine. Vermillion served as the wine's test market, with the city's liquor store the first to stock Valiant Vineyards, selling bottles from $9.25 to $18 each. To commemorate the occasion, Valiant also offered a specially packaged box set of all original five wines for $100. Governor Janklow claimed no. 001.

The public embraced the locally made wine, too. Valiant's first batch of Wild Grape sold out within two months, and the rest sold out a short time later. Although Valiant Vineyards soon began distribution to the larger cities

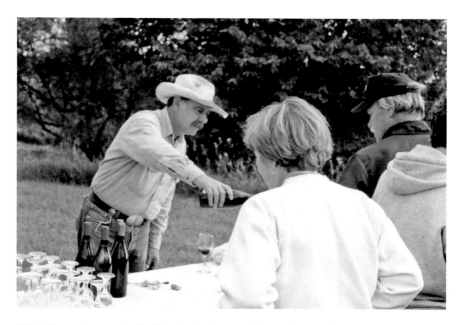

Eldon Nygaard pours wine for friends after the grape harvest in 1996. *Courtesy of Valiant Vineyards.*

of Yankton and Sioux Falls, people would drive from hours away to the Vermillion Liquor Store specifically to buy wine during the early months.

Encouragement came from Washington, D.C., as well. South Dakota's Congressional delegation, which included then Senate Minority Leader Tom Daschle, was enthusiastic about the endeavor and invited the Nygaards to Washington for a tasting event in May 1997. The event was attended by lawmakers and a small group of guests. Daschle, Democratic Senator Tim Johnson and Republican Congressman John Thune were each presented with commemorative bottles. According to remarks printed in the June 20, 1997 edition of the *Argus Leader*, Daschle was "especially proud of the fact that the variety of grape used to produce the wine was developed by South Dakota State University."

In a letter to Eldon and Sherry dated May 22, 1997, Johnson said they would serve as an example to other South Dakota entrepreneurs and that "wine lovers everywhere will be fortunate beneficiaries of your tenacity, vision, and hard work. The taste of your wines was superb, but I am confident that the story of your winemaking will also be compelling to South Dakotans throughout our state—from the arduous hand picking of wild grapes and berries, to the selection of South Dakota based boxing and

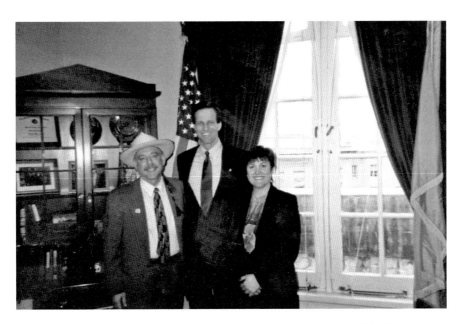

Eldon and Sherry Nygaard with Republican South Dakota Congressman John Thune at a 1997 Washington, D.C. tasting event. *Courtesy of Valiant Vineyards.*

artwork. I can't imagine two people better suited to pioneer the wine making art and profession in our state."

South Dakota became the forty-second state to be represented in the American Vintners Association. Eldon became actively involved in the organization and was elected to its board of directors. He used this position to lobby for farm policy and help secure grant money for the South Dakota wine industry, including a $3 million research grant for Fennell's viticulture program at SDSU.

By 1997, eight grape varieties were growing at the Viborg farm, including French Vinifera, Foch and De Chaunac, in addition to Valiant and several of the French hybrids developed at U of M. Weeds were controlled with the planting of genetically engineered Round-Up soybeans in the surrounding fields. This situation stopped nuisance vegetation without damaging the vines, as there is little drift with Round-Up.

The Nygaards planned to ramp up production in the fall of 1997 and then break ground on a winery in 1998. A seven-thousand-foot log cabin planned to be built on their Viborg-area property would not only serve as a base for winemaking but also house a tasting room and a destination bed-and-breakfast. Production did double and quadruple in subsequent seasons,

but as often happens with the best-laid plans of mice and men, not all of the farmers in the area were concerned with creating ambiance for wine-sipping tourists. The construction of a nearby large-scale hog operation turned the Viborg property into a less than desirable location for a relaxing, pastoral vacation.

The couple's attention turned toward Vermillion, where they lived, where Eldon worked and where they were producing wine in a warehouse space. The town's population of more than ten thousand, its status as home to the University of South Dakota and its location six miles west of Interstate 29 made it a promising place for a Plan B. The Nygaards purchased property on the western edge of town and built their winery into the side of a steeply slanting hill with a miles-wide view of the Missouri River Valley.

Ground was broken in 1999, and Valiant Vineyards opened in 2000. The fifteen-thousand-square-foot building stands three stories, with a walkout basement dedicated to winemaking and bottling. The main floor is home to the tasting area and an event space. The second story is multipurpose, with seven guest rooms, a conference center and, best of all, a large covered deck with a million-dollar view of the wide, green valley. Wild grapevines hang from the winery's shaded front porch, cover the fences and snake through the trees behind the building.

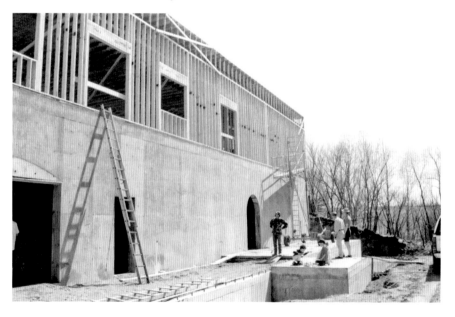

Valiant Vineyards' fifteen-thousand-square-foot winery and bed-and-breakfast under construction in 1999. *Courtesy of Valiant Vineyards.*

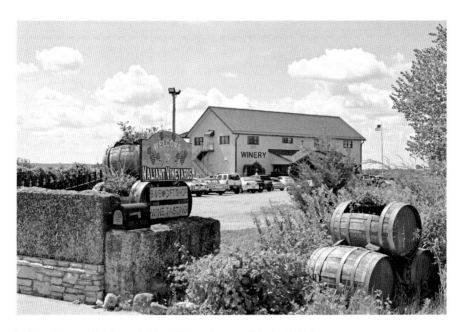

Valiant Vineyards winery in Vermillion. *Courtesy of Denise DePaolo.*

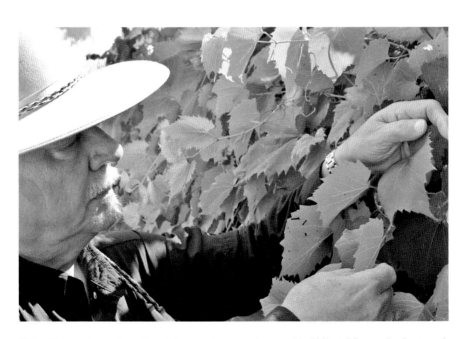

Eldon Nygaard examines the wild grapevines growing outside Valiant Vineyards. *Courtesy of Denise DePaolo.*

Over the next decade and a half, more and more South Dakota winemakers applied for commercial licenses, with the number hitting thirty in 2016. In the early years, the grape growers and winemakers attempted to band together with farmers of other specialty crops, like watermelons, pumpkins and honey, forming the South Dakota Specialty Crop Growers Association. Nygaard served as the group's charter president.

As the number of winemakers reached and exceeded two dozen, however, it became clear that their interests would be best served by forming their own lobby. This became the South Dakota Wine and Grape Growers Association. Nygaard, who was elected to a two-year term as president in 2016, hopes that all South Dakota wineries will join the organization. He would also like to see the state's brewers and distillers join with its vintners to form one unified State Beverage Alcohol Producers Association.

As of 2016, the Nygaards have grown their repertoire to roughly two dozen wines, including the official wine of the Sturgis Motorcycle Rally. Their bestseller has been Tickle Me Rhubarb, which featured an elementary school photo of wine-loving Eldon.

In addition to wines, the Nygaards have begun distilling artisan spirits as part of their Stone Faces brand. They have expanded to western South Dakota as well, with Stone Faces Winery in Hill City and a tasting room at Christmas Village in Rapid City. Between talk of even more expansion and son Leif's emergence as a sixth-generation winemaker, the Nygaard name promises to remain synonymous with South Dakota wine.

FRUITS OF THE PRAIRIE

W hen one says the word *wine*, most people immediately assume they are referring to a beverage made from fermented grape juice. Most of the time, they would be correct. But for early South Dakotans, the only available grapes were the wild *Vitis riparia* growing along riverbanks. These flavorful but thick-skinned grapes made lovely jellies but were less than ideal for winemaking, and the annual yield was determined by the whims of Mother Nature. Those with heritage in the cool climates of Scandinavia, Germany and the Czech Republic, however, were already familiar with wines made from fruit, vegetables, flowers and herbs—and the wide, grassy plains of the Dakotas had plenty to pick.

Humans have survived for thousands of years by foraging edible plant life. Early South Dakotans were no exception. Families would set out with baskets and bowls, plucking fruit from stands of trees and bushes near their homes. Once shelter was built—usually from eighteen- by twenty-four-inch bricks of sod, weighing roughly fifty pounds each—planting a garden or an orchard was often a top priority. Much of this producc supplemented a simple frontier diet, but the excess was used to make preserves, jams and wine. As one South Dakota winemaker commented, "There were no 7-Elevens on the prairie."

For many of South Dakota's modern vintners, making wine from fruit was a necessity. Planting a vineyard is a capital-intensive undertaking. Between plants and trellises, it could cost upward of $10,000 per acre to start. Then, on top of that, it takes several years to produce grapes of any quality. Bob

Weyrich of the South Dakota Department of Agriculture emphasized that viticulture is not for the weak of heart, as the break-even point typically does not come for a decade. Fruit wines were a means to an end, allowing winery owners to recoup some of their costs and begin establishing a brand while waiting for their vineyards to produce. For most wineries, even after their grapes came in, local demand constituted continued production of fruit wines. Their customers are the descendants of the pioneers, after all.

As agriculture is the state's top industry, a wide variety of fermentable produce is available locally. Many winemakers grow their own rhubarb and gather their own elderberries, but most fruit comes from specialty farms within a two-hundred-mile radius. Each summer, truckloads of strawberries, blackberries, blueberries, pears, plums, chokecherries, chokeberries and black currants arrive at the wineries, brimming with natural sugars.

Pleasant as they might be, non-grape wines are often regarded as "less than" by purists. In fact, to be considered wine in the European Union, a beverage must be composed of fermented grapes, and in the United Kingdom, fruit wines are widely called "country wine"—banished, if only by vernacular, to the realm of "country cousins" and "country mice." While a vintage of strawberry or plum might not be as nuanced as Napa Valley Cabernet Sauvignon, in South Dakota, the production of fruit wines both for personal and commercial consumption is as prevalent today as it was on the open prairie.

THE BASIC FORMULA

Wine can be made from a wide variety of plants, including stone fruits, dandelions, wild berries, apples, pears, pumpkins and even rhubarb. If it can ferment, it can become wine.

Fermentation is achieved when sugar is converted to alcohol with the help of bacteria or yeast. The addition of a sweetening agent like sucrose, honey or sugar is sometimes necessary to raise the alcohol level and to make the wine pleasantly drinkable.

To get started, one should have a three-gallon stoneware crock, three one-gallon jugs, two airlocks with rubber stoppers, a siphoning tube, a funnel and a cheesecloth or a fine mesh strainer.

For the wine, have four pounds of frozen fruit, one gallon of water, two pounds of sugar, one package of wine yeast and a teaspoon of yeast nutrient.

In order to make good wine, fruit must be picked at peak ripeness. Many winemakers freeze all of their fruit, aside from their grapes, before processing it. This breaks the fruit down, making it easier to work with. It also means that fruit wine can be made year round.

In the crock, boiling sugar water is poured over the frozen fruit, killing any harmful bacteria. After that mixture sits covered with a cloth for a day, one must mash up the fruit further and add the yeast. Stir once a day for a week and then strain into two of the glass jugs, leaving a few inches at the top. After a month, the finished wine from both jugs can be siphoned carefully into the remaining jug.

FRUITS OF JOY, FRUITS OF FRUSTRATION

Not all plants are built the same. Some are ideally suited for wine, while others need some help. Some can be eaten raw, while others are only palatable when cooked. And when it comes to rhubarb, stay away from the leaves if you value your health.

Don and Susie South, owners of Strawbale Winery in Renner, produce thirty different wines, many of which are fruit-based. Their selection runs the gamut from a classic like cherry wine to more experimental varieties, like the jalapeño-cranberry Burning Bog, which Don says tastes just like pepper jelly. The Souths explain that working with multiple growers from different parts of South Dakota is important. By diversifying, if a hailstorm or an early frost destroys a crop an hour north, they are still able to get what they need from someone in an unaffected area. If a similar act of nature had happened in Dakota Territory, a family would have been out of luck.

The Souths' favorite fruit to work with is black currant, which Susie describes as a "mouthful of flavor." Black currant is an edible berry related to the gooseberry. It is bluish-black in color and makes a deep-purple juice. Strawbale Winery's Black Currant wine, with its bright, rich sweetness, is one of its most popular. In the summer, it is made into slushies during the winery's weekly live music events. The Souths make a fortified version of their Black Currant, as well. They also use black currant as a blending fruit, combining it with the dry, red Frontenac grape for their signature Prairie Storm. The rest of their fruit wines contain no grapes and are made with 100 percent local produce.

Strawbale Winery owner Susie South checks the chemistry of a new vintage. *Courtesy of Strawbale Winery.*

The Souths have less favorite fruits to work with, too. Don said that strawberries are the worst. He dislikes that they are mushy and leave a lot of lees, which are the dead yeast cells. He says wild plum is difficult to work with, too, for similar reasons. But these fruits make great wine, and strawberry rhubarb is a guest favorite, so the toiling continues year after year.

DANDELION WINE

Widely considered nuisance vegetation today, dandelions were once regarded as medicinal and have a long culinary history. This "weed," known for its bright-yellow petals that give way to downy seed balls, is rich in protein, calcium, iron, vitamin A and vitamin C. It is known to aid the liver and relieve rheumatism. Dandelion greens can be picked before the flower blooms and make a pleasant addition to salads or other recipes that call for fresh herbs. After the flower blooms, the greens become increasingly tough and bitter.

Just as the leaves are the sweetest when the plant is young, timing is also of the essence when the desired result is wine. Making dandelion wine is a labor-intensive yet highly rewarding undertaking. The flowers must be picked at their peak, which only lasts for one to two weeks each summer.

BOTTLING SUMMERTIME

Jeff and Victoria Wilde, owners of Wilde Prairie Winery in Brandon, are two of the few winemakers still selling dandelion wine in South Dakota. Victoria described the process as grueling. The dandelions are collected from the vineyard, where no chemicals are sprayed, by crawling on hands and knees and tossing the heads into bowls. The Wildes then peel out the petals, as the greens will make the wine bitter. Then they ferment the petals with water, sugar and fruit acid. It takes six cups of dandelion petals to make five bottles of wine. In Wilde Prairie's best year, more than eighteen gallons was produced—the equivalent of ninety half-bottles (375ml).

Wilde described getting the petals into the tank as the most difficult part of the process. Once the ingredients are in the tank, she says production is easy, and the wine clears really well. Like her other fruit wines, Wilde doesn't put dandelion wine out for tasting for two to three years, in order for it to develop flavor and lose some of its "edginess." What results is a light-bodied, pale-yellow dessert wine.

A DANDELION DISASTER

Dandelion wine is not for beginners, unless they are wildly ambitious. Even some professional vintners, like the Souths of Strawbale Winery, will not bother. "Life is too short," they said. The work is tedious and the yield, although very tasty, is small when weighed against the labor. For those working from verbal instructions or an old handwritten family recipe, the chances of disaster increase dramatically. Many recipes don't specify that the petals must be removed from the head or to allow as little green as possible into the mixture. The more greens in the mix, the more aggressive the odor. Some odor is normal as the petals ferment, but it should not be disruptively potent.

In the July/August 2008 issue of *Countryside & Small Stock Journal*, writer George Sims reflected on his misadventures with dandelion wine in his column, "The Hapless Homesteader." Following a recipe from Euell Gibbons's *Stalking the Wild Asparagus*, Sims gathered a gallon of dandelion flowers and placed them in a two-gallon pot covered in a gallon of boiling water, with the intention of letting them steep for three days. After that, the liquid should have been strained and boiled with citrus, sugar and ginger

before the addition of yeast. Instead, Sims wrote that he was sidelined after step one, as the three-day "tea" (which included the greens) smelled of "human vomit" and awoke his entire family, forcing them to leave every window open for two days.

A GOLDEN LEGACY

Eldon Nygaard, owner of Valiant Vineyards, remembered the dandelion wine made by his German neighbor, Selma Stotz, fondly. After her death in the early 2000s, he received a call from Selma's son, Donald. He was cleaning out the basement of the old Viborg farmhouse when he found ten one-gallon jugs of wine. Donald asked if Nygaard would help determine what they were and if they were drinkable. Nygaard happily agreed.

What had been found was a veritable wine time capsule. The jugs were all covered in dirt and dust. Some had masking tape labels with writing barely visible. Nygaard approached the project like an archaeologist on a dig, using an air hose to remove the dust and then carefully cleaning off the jugs. Some had twist caps, while others had corks ready to crumble.

When the liquid was siphoned out of the jugs, seeds were found in the sediment, which allowed Nygaard to better identify the wines. There were pear, wild grape, cherry, mulberry and dandelion varieties. Some, Nygaard recalled, were very high in alcohol.

Next came the process of re-filtering and checking the chemistry to make sure they were safe to drink before packaging the wines in 375ml bottles. Some of the bottles went into the Valiant Vineyards wine library, but most made their way back to Donald, so he could enjoy them with his children.

Later, Nygaard was invited to the wedding of Donald's son in Austin, Texas, and Eldon brought along a six-pack of the dandelion wine, which was at least fifty years old by then. At the reception, Nygaard stood and shared the story of the groom's family's pioneer background. Then Nygaard told the assemblage about Stotz's passion for winemaking and pulled out the small bottles of dandelion wine. Everyone brought a glass up for a sample, simultaneously bringing Selma Stotz into the occasion. Nygaard said there wasn't a dry eye in the house, and he marveled at how a bit of wine from a cellar in Viborg, South Dakota, could transcend fifty years and more than one thousand miles.

After half a century in a jug, the wine itself had become a yellow-brown color, with a rich taste more reminiscent of a brandy than a wine. The alcohol content had escalated to roughly 19 percent, in Nygaard's estimation, due to the addition of sugar and particularly good yeast.

The dandelion wine wasn't the only vintage to transform over the decades. The Stotzes' pear wine had transformed from pale yellow to a deep-gold dessert wine. What made the wine even sweeter was Nygaard's memories of the tree where those pears had been picked.

Valiant Vineyards doesn't make much fruit wine anymore, but Nygaard's fondness for it remains. At the Great Dakota Wine Festival, held each year at the Vermillion winery, hobbyists are encouraged to enter the home winemaking contest. Entries in 2016 included sumac wine, sweet basil wine, raspberry wine and a sparkling apple mead flavored with lemongrass.

RHUBARB WINE

The rhubarb patch at Tucker's Walk Vineyard near Garretson. *Courtesy of Denise DePaolo.*

Tart, complex rhubarb is a popular addition to cakes and pies, often paired with strawberry. In the wine bottle, rhubarb and strawberry mingle well, too. When it flies solo, sugar or honey is essential to make palatable the stalks of this deep pinkish-red vegetable masquerading as fruit. The leaves, however, are poisonous. Two centuries ago, the English called rhubarb "pie plant," and when they and Nordic peoples came to the United States in the early 1800s, they brought it along.

In South Dakota, the unrivaled "rhubarb king" is Jan Sanderson of Brookings County's Sanderson Gardens. He has been growing rhubarb on his farm near Aurora for more than three decades, and he has bred his own bright crimson, extra-tender variety called Sanderson Red. Sanderson has also sold strawberries to Brookings brewery Wooden Legs Brewing Company and welcomes guests to pick their own berries and pumpkins at the farm.

The prevalence of rhubarb makes it a common plant for experimentation among South Dakota winemakers. Some years back, Tucker's Walk Vineyard owner Dave Greenlee tried out what he believed was an old German recipe. Among the ingredients was clove. Dave went a bit overboard with the potent spice, causing the smell to be overwhelming. He attempted to move forward with the vintage, calling it Clo-Barb, but it was not popular. He came to call it "toothache medicine" for the pain-relieving qualities of clove oil. Ultimately, it went down the drain, relegated to the "learning experience" column.

CHOKECHERRY WINE

This wild cherry grows on short, shrubby trees throughout South Dakota and the Great Plains. Traditionally, it was a popular fruit in the diets of local Native American tribes. When white settlers arrived in the Dakotas, they began picking this fruit, which ranges from deep red to black, and making jellies, syrups and wines—with a healthy dose of added sugar, of course.

Many of the state's current winemakers think of it as "the quintessential South Dakota fruit," due to its prevalence and popularity in the area. This is the type of wine Greenlee remembered his father making, and now he makes his own chokecherry wine to sell at Tucker's Walk. Schadé Vineyard and Winery, Wilde Prairie Winery, Prairie Berry Winery and Strawbale Winery each make a version, as well. In fact, the odds are in favor of finding a chokecherry wine on any tour of South Dakota wineries.

In spite of the chokecherry's long history on the table and in the wine bottle, some were taken aback by the fruit's sinister-sounding name when it was proposed for mass production. South Dakota's winemakers and, by extension, wine drinkers have Prairie Berry's Sandi Vojta to thank for the word appearing on labels. She worked with Professor Anne Fennell at SDSU to provide clarity on the fruit's chemical makeup, demonstrating its fitness for consumption.

In a letter dated April 21, 2000, Dr. Fennell wrote to Vojta, explaining that searches of both the AGRICOLA Database (National Agriculture Library) and NAPRALERT (database of natural products and organisms) yielded no evidence of thujone, a potentially harmful chemical compound, in *Prunus virginiana* (chokecherries or bitter-berries). This research helped pave the way for chokecherry wine to land on grocery shelves and in tasting rooms throughout the state of South Dakota.

Black Chokeberry Wine

The chokecherry is not to be confused with the black chokeberry. Another popular fruit for South Dakota winemakers to play with, this black-skinned berry can be sour enough to make one's mouth pucker. It is also known as "aronia." Many South Dakota winemakers have a black chokeberry variety or blend it with complementary grapes, but now this fruit is also being heralded for its antioxidants. Schadé has started selling non-alcoholic aronia juice at its Volga tasting room, billing the rich, dark, slightly sweet liquid as the "King Kong" of antioxidants.

Chokeberries outside Strawbale Winery near Renner. *Courtesy of Denise DePaolo.*

The Elusive Fruits

There are only two fruits in the Strawbale Winery repertoire that are not available consistently or locally to the Souths. First is the cranberry. Many wineries, including Strawbale and Hill City's Prairie Berry, make a cranberry wine because of popular demand. Cranberries, however, do not grow in South Dakota, due to a lack of bogs, and must be shipped in from Wisconsin. The other is the buffaloberry, also known as "shepherdia."

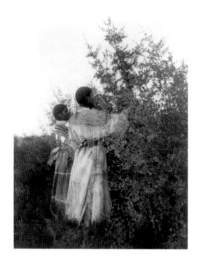

Native American girls pick buffaloberries. *Courtesy of the Library of Congress.*

Buffaloberries are native to South Dakota and most of the Great Plains region. In September 1804, Lewis and Clark recorded the plant in their journals, along with a detailed sketch. According to Prairie Berry Winery's website, the berries are thus named because "buffalo used to rub against the thorny bushes in the spring to help shed their winter coats." Another theory says the berries were so named because local Native American tribes had traditionally used them to flavor buffalo meat in their pemmican.

The shrubs have foliage similar to a Russian olive tree, with small, long, silvery-green leaves. The deep-red berries are bitter tasting until they are touched by frost. The frost causes the berries to sweeten, and they can then be made into jellies, cranberry-like sauces and, of course, wine.

Like many wild fruits, production is cyclical for buffaloberries, and the Souths are only able to get a crop every three to four years. Harvesting the berries brings an additional challenge. As Susie South explained, one must wait for the first frost for the berries to sweeten, lay down drop cloths around the bush and hit the bush with a baseball bat to knock the berries loose in order to avoid the sizable thorns.

THE FUTURE OF FRUIT

Although the season is short, growers continue to push the boundaries of what can be cultivated in South Dakota. Farmers like Brookings County's Jan Sanderson are working to make better market-ready produce. In the lab, researchers like SDSU's Anne Fennell are exploring the properties that allow fruit to survive bitterly cold winters on the Great Plains. And organizations like the South Dakota Specialty Producers Association are promoting the cultivation of diverse crops like hops, honey, fruits and vegetables in an effort to elevate the quality of locally grown produce. Considering its long, slow journey from cellar to store shelf, and its deep-rooted history within local families, South Dakotans will likely continue their love affair with fruit wines for generations to come.

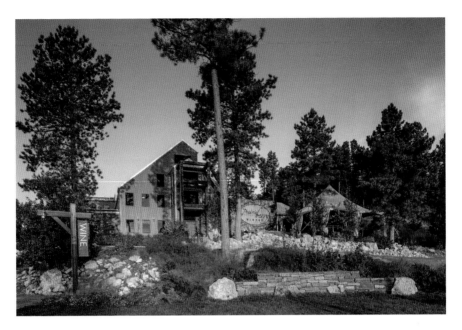

Prairie Berry Winery outside Hill City, with architecture that blends the mining and farming heritage of South Dakota. *Courtesy of Prairie Berry Winery.*

Sandi Vojta starting the brewing process of one of her unique beers. *Courtesy of Prairie Berry Winery.*

Above: Sandi crushing Blaufrankisch grapes for her Anna Pesä wines, in honor of her great-great-grandmother from Moravia. *Courtesy of Prairie Berry Winery.*

Left: Wild grapes (*Vitis riparia*) like those the Lewis and Clark Expedition would have encountered. *Courtesy of Denise DePaolo.*

Dr. Ronald Peterson sips a glass of wine made from his Valiant grapes. *Courtesy of Bob Weyrich.*

Elderberries ripen on the Schade property near Volga. *Courtesy of Denise DePaolo.*

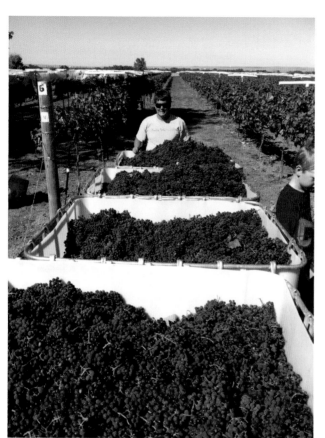

Left: Matthew Jackson with his Marquette grapes at Belle Joli' Winery's vineyard outside Belle Fourche. *Courtesy of Belle Joli' Winery.*

Below: La Crescent grapes growing in the vineyard. *Courtesy of Denise DePaolo.*

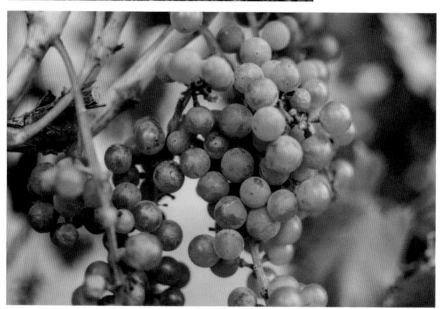

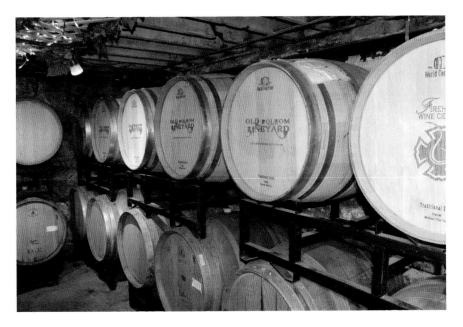

Firehouse Wine Cellars' barrel room with the solera system for aging Tradition, the port made from Marquette grapes. *Courtesy of Kara Sweet.*

Valiant Vineyards' Great Dakota Wine Fest event, featuring South Dakota wines. *Courtesy of Denise DePaolo.*

Above: Prairie Berry Winery's Black Currant Sangria. *Courtesy of Prairie Berry Winery.*

Left: Firehouse Wine Cellars' Rushmore Riesling pairs beautifully with light seafood dishes, like linguini with scallops. *Courtesy of Firehouse Wine Cellars.*

Above: Wines made from South Dakota Marquette grapes pair well with robust meals like the traditional French stew beef bourguignon. *Courtesy of Firehouse Wine Cellars.*

Below: Firehouse Wine Cellars' Tradition—port-style fortified wine aged in a traditional solera barrel system. *Courtesy of Firehouse Wine Cellars.*

Crush of South Dakota–grown Marquette grapes at Firehouse Wine Cellars in downtown Rapid City. *Courtesy of Kara Sweet.*

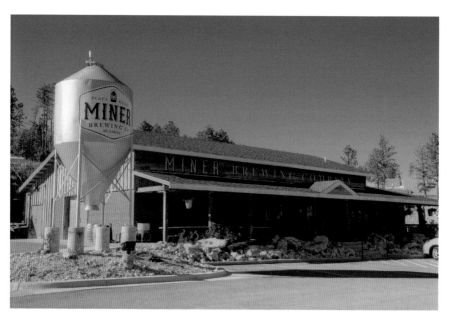

Miner Brewing Company, winemaker Sandi Vojta's brewery, next door to Prairie Berry Winery. *Courtesy of Prairie Berry Winery.*

The Vojtas' basement in Mobridge, where the first commercial bottling of Prairie Berry wines took place. *Courtesy of Prairie Berry Winery.*

Volunteers pour wine samples for guests at the 2016 Great Dakota Wine Fest at Valiant Vineyards. *Courtesy of Denise DePaolo.*

Left: Award-winning wines from Rosholt's With the Wind Vineyard & Winery. *Courtesy of With the Wind Winery.*

Below: Bird nets covering beautiful South Dakota vines. *Courtesy of Kara Sweet.*

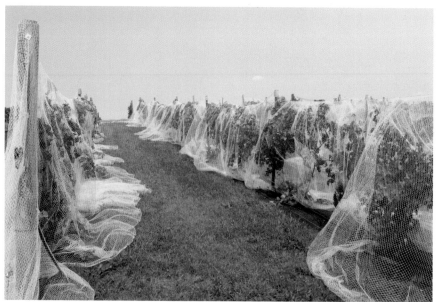

Above: Schadé Vineyard and Winery's Signature Red in the South Dakota snow. *Courtesy of Schadé Vineyard and Winery.*

Left: Toasting to another beautiful South Dakota day. *Courtesy of With the Wind Winery.*

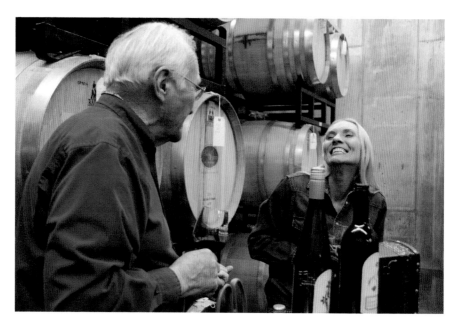

Ralph Vojta and his daughter, Sandi, celebrating their Anna Pesä wine release. *Courtesy of Prairie Berry Winery.*

A cluster of Marquette grapes ripening in the Tucker's Walk vineyard. *Courtesy of Denise DePaolo.*

A variety of Valiant Vineyards wines ready for sampling at the 2016 Great Dakota Wine Fest. *Courtesy of Denise DePaolo.*

Firehouse Wine Cellars' Brianna Edelweiss wine. *Courtesy of Kara Sweet.*

Above: Mike Hackett pouring Firehouse Wine Cellars' wines in downtown Rapid City. *Courtesy of Kara Sweet.*

Left: A glass of South Dakota wine at Schadé Vineyard and Winery. *Courtesy of Denise DePaolo.*

Wine enthusiasts enjoy wine on the patio of Belle Joli's tasting room on Main Street Deadwood. *Courtesy of Kara Sweet.*

Special-edition wines from Schadé Vineyard and Winery. *Courtesy of Denise DePaolo.*

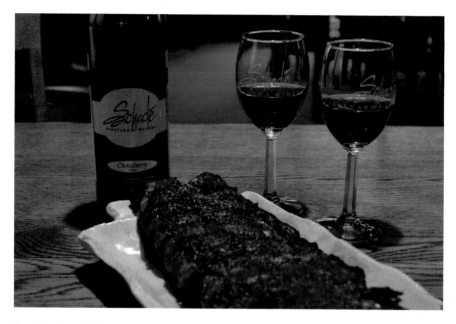

South Dakota chokecherry wine from Schadé Vineyard and Winery. *Courtesy of Schadé Vineyard and Winery.*

Mike Gould pouring Marquette wine in his Old Folsom Vineyard. *Courtesy of Kara Sweet.*

Chapter 5

GROWING GRAPES
IN SOUTH DAKOTA

HERITAGE

Even the most recent grape growing in South Dakota is deeply rooted in family tradition. Mike and Marnie Gould's Old Folsom Vineyard south of Rapid City may have been planted just under ten years ago, but the idea for this endeavor goes back generations.

Gould's grandfather Anton Finco boarded a ship to cross the Atlantic Ocean to come to America. He was leaving his hometown, Galio, near the Dolomites of Italy. He was hungry, for both food and a new beginning. He was only nineteen. Coming to the United States was the answer for Anton, the one way he saw to have a better life. He was highly motivated to succeed when he settled in Ironwood, Michigan, to work as an iron miner. Anton married and raised his children as Americans. His winemaking was one aspect of his Italian life he was not willing to leave behind.

Anton's daughter, Mike's ninety-five-year-old mother, Antonette, distinctively remembered the grapes coming to Anton and his neighbors in Ironwood via railcars from California. The front porch would be filled with grapes, most likely the Alicante grape, a thick-skinned fruit that would easily survive the long trip from the West Coast. As a child, Antonette saw the barrels in the basement filled with fermenting liquid as the house filled with the smell of wine. Antonette often had the chore to run downstairs to the basement to get a few bottles of wine, which was enjoyed as their beverage with meals.

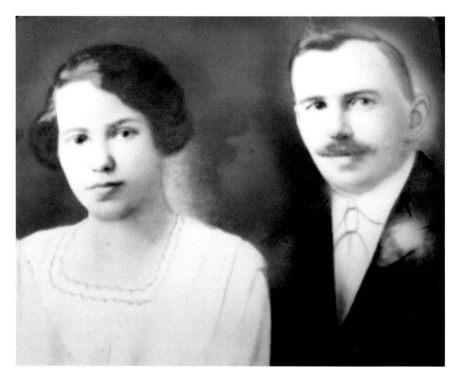

Mike Gould's Italian grandfather, Anton Finco, and Anton's wife, Anna Forte Cervo Finco. *Courtesy of Mike Gould.*

As Antonette got older, she and other relatives would help with the wine. Gould began this task as well, learning the tricks of winemaking just as his grandpa did back in Italy. Gould and his siblings were often given a small glass of wine, usually with a biscotti. This may have been Anton's trick to babysitting his young grandchildren; it didn't take long after this Italian treat until most of the children were quietly napping.

These fond memories of Gould's heritage led him to always have an interest in wine, though it would be nearly forty years before his career in insurance would allow him to actually grow grapes.

THE BEGINNING

In 1991, Gould joined the Fatboys Partnership with Bob Fuchs and others to open Firehouse Brewing Company in downtown Rapid City. Gould always

had a "passion for wine, the wine side, and growing grapes," although that wasn't an option until after 2005. On a family trip to the French Riviera in 2007, he began studying the vineyards and soil there. He noticed that the acreage he owned outside of Rapid City had calcareous soil similar to many areas in France.

Gould came back to South Dakota and surveyed the soil at his soon-to-be Old Folsom Vineyard. In 2008, he and his wife, Marnie, planted the red grapes Marquette and Frontenac and the white grapes Brianna and Frontenac Gris. The following year, the Goulds added La Crescent. Over the course of the next eight years, Gould increased the plantings of Marquette and added the red Petite Pearl grape, making nearly two-thirds of his plantings red, with the majority of these being the promising cold-hardy Marquette. These grapes would become the backbone for the Firehouse Brewing partnership's newest endeavor of making wine at Firehouse Wine Cellars.

The Goulds "would plant 40 acres [of vines] in a heartbeat" if they had the labor to provide the work those vines would require. Unfortunately, this is one of the drawbacks to growing grapes in South Dakota: there is no agricultural workforce with the skill set to help Gould in his vineyard. Therefore, at Old Folsom Vineyard, the workforce is Mike and Marnie. They do all of the manual labor, such as planting, pruning, weeding, cultivating and trellising. They call on volunteer helpers for yearly harvests, having friends, family and wine club members bring in the thousands of

pounds of fruit the vines grow in a good year.

The biggest hurdle for grapes in the Mount Rushmore State, of course, is the weather. Obviously quite different than other wine-growing regions of the world, South Dakota is cold—some winters, *really* cold.

Top: The work begins to dig irrigation lines and prepare the acreage at Old Folsom Vineyard outside of Rapid City. *Courtesy of Mike Gould.*

Bottom: Planting the vines at Old Folsom Vineyard outside Rapid City. *Courtesy of Mike Gould.*

This is why hybrid grapes and the research done to develop and grow these special grapes is so important to the budding wine industry here. The hybrids growing on Old Folsom Road can withstand deep winter freezes without suffering winter kill and can ripen in the very short midwestern growing season. The Goulds have embraced the new science of grape growing to learn as much as possible about how to grow hybrids and make wine from these special vines.

Late frosts in the spring are always a concern, as sometimes even early June can see a hard freeze. Hail is another serious worry. In 2013, three separate and very destructive hailstorms hit the Black Hills. Because the vineyard's white grapes tend to ripen earlier, they were at a very tender phase when an August storm hit, destroying much of the La Crescent fruit on the vines. The Goulds harvested less than four hundred pounds of white grapes that fall. The Marquette grapes, slightly behind in the growth phase, were somewhat protected under their leaves, but they still suffered extreme damage.

Early freezes continue to threaten the grapes until the time they are harvested, generally by mid-September. However, the 2014 harvest was sped up, not just by an early freeze but by one of the earliest snows on record in the area. As he watched the snowflakes fall on September 11, Gould reached out to his group of volunteers to get the grapes off the vines before the fruit was damaged.

In 2015, several weather incidents, including June rain and hailstorms, damaged the grapes during the flowering stage. This is called inflorescence, when the individual flowers that turn into grapes are damaged, thus fewer grapes grow on the vines. Only enough grapes were harvested to make the equivalent of one barrel of wine; this was made into Firehouse Wine Cellars' port.

Gould knows that "one thing doesn't work for all grapes," but he has found some techniques to help with the climate in which he grows. First, trellising the vines can be an effective tool to combat cold weather in the state. To research this problem, Gould's vineyard equipment takes temperature readings every sixty seconds at three feet high and six feet high, with the data fed into his computer system. It clearly shows a difference in temperature in just a couple of inches. Most *Vitis vinifera* vines (the kind that grow the common grapes such as Cabernet Sauvignon, Chardonnay and Pinot Noir) are trained closer to the ground because they are grown in warm-weather regions. Gould is in the process of moving his vines from the current lower wire of thirty inches off the ground—like *Vitis vinifera*—to a higher wire of forty inches off the ground, about chest height. Just this ten inches higher

off the ground can make two degrees' difference in temperature, reducing frost and freeze dangers.

A final enemy to vines in South Dakota is birds. These feathered friends are not friendly to vineyard owners. Bird netting covers the vines from late July through the harvest. This is incredibly labor-intensive work to cover all the vines with the nets and then clip the netting underneath all the vines. Sometimes this doesn't even discourage the birds that much. They can still stand on the nets and bounce up and down to jiggle the grapes free for eating off the ground below or peck through the netting to eat the grapes inside.

Like most who grow grapes to make wine, Gould is an eternal optimist. He has to be. "I always think of next year as *the* year." The harvest will be better, the conditions less severe. Yet he knows there will never be a perfect harvest, just grape growers doing their best with what Mother Nature allows in this rugged environment that is South Dakota.

RECENT HISTORY

Just outside Belle Fourche stands another South Dakota vineyard. These twenty-five acres of vines are cultivated by Matthew Jackson and his family. Although the Jackson family wine roots may not be as old, their wine heritage definitely runs deep.

When they were in their twenties, John and Patty Jackson—Matthew's parents—huddled together dreaming of their future. Their dreams were big, but they were faced with an important choice. It was as if the young couple had two distinct roads diverging in a yellow wood, and they knew they could not travel both.

John had his undergraduate degree from Minnesota, and he and Patty were deciding where their lives should take them next. He applied for dental school, but the backup plan if John did not get accepted into this postgraduate program was to live the hippie lifestyle by moving to Northern California to make wine. There was a region they had heard was booming with new opportunities: Napa Valley.

John and Patty—Minnesota natives—have distinct wine memories. Both of their grandmothers, John's of German descent and Patty's of Irish heritage, made wine in Minnesota using anything from grapes to dandelions. John, whose grandmother was still alive when he was a child, had fond memories

of his grandmother's winemaking and brought these remembrances with him into his relationship with Patty.

Their path was set for them when John was accepted into a dental program, graduated as a doctor of dental surgery from the University of Minnesota and moved to Belle Fourche to practice dentistry. He and Patty always loved wine and grapes, however, and they always planted vines wherever they lived.

In 2000, when Matthew was only in eighth grade, John and Patty decided to plant a half-acre experimental plot of vines in Belle Fourche. The parents thought this was an excellent idea because they had two sons to help them work the vines: Matthew and his brother, Christopher. The Jackson family used this tiny vineyard as a trial endeavor to test what grapes would grow in the South Dakota climate. They planted five varieties of grapes there, including the popular *Vitis vinifera* vines Pinot Noir and Cabernet Sauvignon. Matthew and Christopher planted, pruned, plucked and picked. Through this hard work, the boys quickly learned to appreciate vines and wine, but they also learned which grapes did and did not grow well in the area.

Not many middle schoolers would find this kind of work thrilling, but Matthew's excitement was still palpable as he remembered this early connection to grapes. Matthew's next "aha!" moment for becoming a winemaker was just three years later. While in high school, he attended the University of Minnesota's Cold Climate Grape Conference. He learned of the grapes that would grow best in his South Dakota home. Grapes like Frontenac Gris and La Crescent (grapes Matthew would later grow and use) showed potential. Matthew realized that few others in the country were making wine from these, and another seed was planted in his mind.

Matthew graduated from high school and attended the University of South Dakota. He was a premed major. His parents both truly expected Matthew to go to dental school and join his dad and his brother, Christopher (who had since completed dental school and was practicing in Belle Fourche with John), in the family dental practice. But Matthew's family wine tradition was too strong. That experimental vineyard meant too much to him. Instead, Matthew went to California State University– Fresno and entered the wine program there. In 2009, he finished with his bachelor's degree in enology—which encompassed both the growing of grapes and the making of wine—and moved back to South Dakota.

Matthew chose Fresno State because of the hands-on opportunities there. There was an on-site campus vineyard where students could grow their own grapes. Fresno also had a ten-thousand-case student-run winery. Matthew

John, Matthew and Christopher Jackson planting the family test vineyard in Belle Fourche. *Courtesy of Belle Joli' Winery.*

The Jackson family's original test vines growing in Belle Fourche. *Courtesy of Belle Joli' Winery.*

Matthew and Choi Jackson with their parents at graduation from Fresno State University in California. *Courtesy of Belle Joli' Winery.*

was learning so much while at school that he brought back knowledge to his family vineyard before he even finished his education. This knowledge was put into practice outside Belle Fourche at the newer—and much larger— Jackson family vineyard. Starting with five acres at a time, more and more grapes were planted: La Crescent and Frontenac Gris, which Matthew had learned about at the cold-climate grape conference, and Marquette, a grape newly released from the University of Minnesota in 2006.

These grapes were ready for Matthew when he returned home. They were ready to be made into wine and Matthew was ready to get to work, but he wasn't going to work alone. Matthew had developed more than just wine knowledge while at Fresno State; he also found his wine business partner and wife, Choi. Choi, born and raised in South Korea, was at Fresno State as part of an exchange program earning her chemistry degree. She went back to Korea University and received her second and third degrees there, in business and chemistry, before returning to join Matthew in South Dakota to run the business side of their newly developed winery, Belle Joli'.

The Pros and the Cons

Like other producers, Matthew Jackson sees many difficulties and differences in growing grapes in South Dakota versus other areas. It is hard to find skilled workers to help in the vineyard at the few times a year when many people are needed at once. Weather is also the number one issue Jackson must face. These two concerns joined together in 2013 when Winter Storm Atlas dumped more than two feet of snow on the Black Hills over a two-day period. The Belle Joli' harvest was set for October 4, but because all the roads in the area were closed, harvest was pushed back. As soon as the roads opened, Jackson and his family spent the next five days, at first in deep snow, getting the grapes off the vines. These are definitely conditions growers in California could never imagine.

Although a snowstorm while the grapes are on the vine is definitely unusual, it is not unheard of here. Snow can be a worry in September and October, and Jackson usually lets his red grapes hang until the first weekend in October, depending on conditions. Early frosts are a real concern, however. They can hit in September and threaten for an entire month. Late frosts after bud break in the spring are an even bigger distress. Bud break usually happens in April, and frosts and freezes can happen in the Black Hills through June. Once the cold temperatures are no longer a problem, there is more unpredictable weather in the Midwest—summer hail. Hailstorms can damage vines and grapes all season long.

Animals are another pest for Jackson. Deer must be kept out of the grapes by an eight-foot-tall fence surrounding the entire vineyard. Even with this deterrent, deer sometimes get in and feast on the fruits of Matthew's labors. Birds also threaten Belle Joli's crops. Jackson, similarly, uses bird nets surrounding each trellised vine and clipped underneath. These nets are very expensive, and it is incredibly time consuming to cover and then uncover the vines. This is another time when a skilled agriculture workforce would be a benefit.

Nevertheless, for as many disadvantages as Jackson experiences growing grapes in this unexpected wine region, he sees just as many benefits to the unusual area. South Dakota sees four clear seasons, unlike California, which seems to have a yearlong summer. These four unique seasons mean there is the ability for Jackson to do the vineyard work by himself the majority of the time. During winter, vines truly go dormant in the South Dakota cold, meaning that Jackson can sometimes walk away from the vineyard for a period of time to focus only on winemaking. During the summer, as vines

begin to grow their leafy canopy cover, growth is slow enough that Jackson can make his way through the vineyards to do the work of pruning himself.

Winter cold can indeed kill vines' roots if not using cold-hardy, hybrid grapes, but these low temperatures destroy other pests as well, like the vine killers phylloxera and nematodes. Phylloxera is a small vine louse that eats the roots of the grapevines, killing the vines. Temperatures that fall well below freezing each winter kill these pests so they aren't a concern. Other growers graft *Vitis vinifera* vines onto American grapevine rootstock or use hybrid grapes resistant to phylloxera. Matthew has these solutions covered, as well. Nematodes are worms that eat the roots of vines. If the vines don't perish from this, nematodes also spread viruses to the roots. Once again, cold winters kill these little menaces and take away the problem of vine death.

The Black Hills is a very dry environment, another reason to use hybrid grapes that are drought resistant. This dry climate keeps issues like bugs and mold at a minimum. Matthew Jackson is able to use natural methods

Baby doll sheep Little Buffalo Johnny helping with organic pest and weed protection at Belle Joli' Winery's vineyard outside Belle Fourche. *Courtesy of Belle Joli' Winery.*

for both of these possible problems. He doesn't have to spray chemicals for mold or fungus. Bugs and other pests are controlled with the Belle Joli' geese and baby doll sheep that freely roam the vineyard outside Belle Fourche. The baby doll sheep, Lilly and Little Buffalo Johnny, are just short enough to fit under the lowest trellis wire to keep the vineyards mowed while the bugs are kept at bay. The weather has made it easy to keep the vineyards basically organic; the Jacksons just haven't jumped through the hoops to certify the vineyards as such.

The most important observation Matthew Jackson makes about growing grapes in this area is what a grape grower anywhere might say: "Harvest is always different based on the season and variety. It's different every year. It just depends on the end goal."

Game Changers

The evening sunset glows a golden bronze over the green leaves rustling on the sturdy vines at Tucker's Walk Vineyard, on the eastern side of the state. Dave Greenlee grows many of the same hybrid grapes as Mike Gould and Matthew Jackson. Although Greenlee planted his vines East River, his wine heritage actually stemmed from the Black Hills.

Greenlee's father lived in the Black Hills, near Hill City on Mitchell Lake, and used to make wine from wild chokecherries that grew nearby. As a home winemaker in the 1970s, Del Greenlee used his basement shower to store the wine as it was fermenting. The balloons on top of the bottles would fill with the carbon dioxide from fermentation and then burst, hence the pragmatic reason why the bottles were fermenting in the tub.

Del had a few books on wine and worked with a gentleman who made wine, so Del decided to give it a try, too. Dave claimed that a chokecherry wine his dad made was decent, but the experience of making the wine was incredibly noteworthy. Dave still has the recipe Del used and even used it a time or two as Dave made his transition from environmental scientist to his "retirement" job of wine grower with his wife, Sue.

It all began when Sue went to a workshop and met Elmer Swenson. Those in the wine world know Swenson as the father of the hybrid grape. Swenson figured out that the traditional grapes (*Vitis vinifera*) could be crossed with wild grapes (*Vitis riparia*) to make an entirely new type of fruit that could withstand cold climates. Greenlee said Swenson was a "game

changer." Perhaps Swenson's most famous hybrid—often used today—was the Edelweiss grape. He crossed numerous grapes for the University of Minnesota. Others like St. Croix, St. Pepin and Brianna are still commonly found in midwestern vineyards, as well. This chance meeting with Swenson piqued Sue's curiosity and made her and Dave want to know more. Next, they took a formal course in small-scale commercial winemaking in Nebraska, and their second careers were set.

East River is customarily easier country in which to farm, and grapes are no exception. Greenlee—the first to plant Marquette in the state—planted when Marquette was still being called MN1211 (from the University of Minnesota). He sourced three plants from Ray Winter at Winterhaven Nursery. Dave and Sue carried the babies back to their farm in Dixie cups without ever having tasted any wine made from the grapes. The industry excitement about the new grape was all they needed to be convinced to plant.

The vines were so successful that he planted more in 2008 and 2011, equaling two total acres. Dave saw many benefits to South Dakota grape growing, especially on his side of the state. Receiving twenty-five to thirty inches of rain a year means no irrigation was necessary for his vines. Dave irrigated his Marquette vines the very first year and has not added water to them since. Although August gets dry, that is the perfect time for grapes to ripen in the summer sun.

Compared to the Black Hills, East River's growing season seems almost long. Late and early frosts are a concern, but fall snowstorms are generally not an issue in the east. Hybrid grapes have early bud break, so spring chill is a concern. Greenlee does chuckle as he recalls spring pruning in the snow on cross-country skis one year, but for the most part, pleasant summers and long falls make for perfectly ripened grapes in his vineyard.

Dave echoes the additional advantage of not having to worry about many vine diseases and pests, like phylloxera, since the louse cannot survive a South Dakota winter. This keeps Greenlee from having to graft vines onto special rootstock that is resistant to phylloxera, saving time and money in the long run. Finally, the rich East River soil is so fertile that Greenlee rarely needs to add elements to keep the dirt healthy as other growers might. He has no need to add nitrogen, and only trace amounts of magnesium or potassium are necessary.

Other than certain weather disadvantages, Greenlee again sees the lack of an agricultural workforce as a problem. His vineyards are still small enough that he can prune his 3,500 plants himself. However, it does take a lot of

work, and it is an issue to be considered when thinking of the future of his vineyard and winemaking. At this point, Dave and Sue enjoy the farming aspect of Tucker's Walk so much that they look forward to the "slow and steady, modest growth" their vineyard continues to make.

Best Practices

Dr. Anne Fennell had always been interested in agriculture, in growing things. Even before she went to college in Iowa, she worked in an orchard. "You could say I've been haunted by grapes." If grapes haunted her, she hunted them, spending an entire career working to find what grapes would grow best in the harsh climates like that in South Dakota. She went to work at the University of Minnesota after she finished her PhD and started studying cold-hardy grape varieties. Minnesota had just passed its own farm winery law at the time, so the interest in vines that would grow there was great.

First, Fennell looked at grapes to see the differences between continental climates (areas with no coastal or oceanic influences that generally have hot, dry summers and cold, severe winters) and coastal climates (areas where large bodies of water influence and moderate weather patterns). Soon, she came to South Dakota to work with native grapes and hybrid grapes, specifically many that were developed at the University of Minnesota. Her research was funded by several different grant programs, including the National Science Foundation and the Northern Grapes Project. No matter the project, the goals ended up being similar: find vines that would succeed in South Dakota and the surrounding states.

Dr. Fennell's work took place in both the field and the lab. In the field, she would study winter survival, fruit quality and plant dormancy. A plant population was required for proper study, so she often found herself in the vineyard in unpleasant weather. In the lab, she would test the field conditions to draw conclusions of the growing process. She often looked at different climate zones and the grapes that would grow in these varied zones. For instance, South Dakota, North Dakota and Nebraska are part of a similar climate zone. The weather here is quite different than other zones, such as Ohio and Michigan. Checking performance, production and survival across the different locations was quite important for researchers to draw conclusions on what grew best where.

Dr. Anne Fennell working in the winter-hardy vineyard with Dr. Ronald Petersen. *Courtesy of Bob Weyrich.*

Over the course of her work, Dr. Fennell found that research showed that most success in the state of South Dakota came from vines developed by the University of Minnesota and/or Elmer Swenson (either when he was working at U of M or on his own): La Crescent, Marquette, Frontenac Noir, Frontenac Gris, Frontenac Blanc and Brianna. These complex hybrids are similar to traditional *Vitis vinifera* vines in many ways, but since they are crossed with wild grapes, they are different. They have different flavors and different aromas. With this comes both good and bad elements for winemaking. She declared, "The thing about these cultivars is, number one, they are of wine quality in [that] you can grow them in this region, and that's a major feat itself."

Not all of the investigation showed what grapes grew well in the state. In fact, many grapes were shown not to grow well here. The *Vitis vinifera* varieties did not do well, even when attempting almost-strange growing conditions, like trying to train the vines along the ground and heat the ground below. Kay Gray, a hybrid grape that grows well in neighboring Nebraska and some parts of the state, did not have success in all areas of South Dakota. Dr. Fennell believed it was because the vines did "not start acclimating early enough in the fall."

Anne Fennell learned that like many aspects of life, growing grapes is all about timing. The grapes that do well in such harsh environments are the ones that acclimate and go dormant in the exact right time of the fall so they don't die from autumn frosts. They are the vines that experience bud break on the perfect day so they do not perish from spring frosts. Dr. Fennell admitted that there is still much to learn about the grapes and making wine from them: "I would like to see growers reliably producing four tons or more per acre, and that required grapevines that are surviving well and not succumbing to damage." However, Dr. Fennell's research has made the current state of South Dakota grape growing possible.

Chapter 6

WINERIES OF THE EAST

S outh Dakota sprawls across 77,184 square miles, with Wyoming and Montana to the west, Iowa and Minnesota to the east, Nebraska to the south and its fraternal twin, North Dakota—admitted to the Union on the same day in 1889—sharing the full 360 miles of its northern border.

The Missouri River divides the state of South Dakota into two neat halves, and it is by this geographical barrier that people categorize themselves—"West River" and "East River." To South Dakotans, the divide is geographical as well as social. Certainly with some exceptions, the eastern half of the state skews a bit more liberal than the west. The "big city" in the east is Sioux Falls, with a population of 173,000, as of 2016. The main population center in the west is Rapid City, with a population of nearly 74,000, as of 2015.

In the east, there are farmers; in the west, it's ranchers. The state's western half is populated more sparsely than the east, with seemingly endless grazing land and stunning vistas. It is also home to the craggy, jagged moonscape of Badlands National Park and the deep green pines of the Black Hills National Forest. The surest way to spot an imposter is to ask someone which he is, East River or West River, and find he does not understand the question.

East River is less geographically dramatic than the west, with rolling farmland, where corn and soybeans grow in the summer, and hunters from all over the globe shoot pheasants in the fall. The east is also where the majority of South Dakota's grapes are grown and where a burgeoning wine trail exists. Most of the wineries can be reached within a twenty-minute

drive of Interstate 29, which runs north–south, hugging the state's eastern border. The distance between wineries, however, can be significant.

The winemakers of South Dakota are a diverse lot, with wildly varying professional backgrounds. Some come from families with home winemaking, or even bootlegging, traditions. Others fell in love with the lifestyle while on vacation. But they have much in common, too. They all know the heartbreak of a crop destroyed by hail or an early frost. They have all spent countless hours stemming, crushing and mashing, only to have a batch turn out terribly. On the flipside, they have experienced the pride of seeing their label on a store shelf for the first time, reveled in the first taste of a new vintage and had the knowledge that they were in the process of making history as the first generation of South Dakota commercial winemakers. This chapter visits some of East River's wine destinations.

With the Wind Winery

Rosholt is located in the northeast corner of South Dakota, seven miles off I-29. The first settlers arrived after the Homestead Act of 1862 opened the Sisseton Wahpeton tribal land, offering free plots for those willing to farm them. In 1913, the town of Rosholt was formed when Julius Rosholt brought a railroad through the area, allowing farmers to export their crops. Agriculture remains the lifeblood of Rosholt, but on one farm, the crop isn't corn, wheat or soybeans—it's grapes. Brianna, Frontenac, Frontenac Gris and King of the North, to be exact.

Rosholt native Jeremiah Klein and his wife, Lisa, who is originally from Garretson, are longtime hospitality and tourism professionals. When they returned to South Dakota after a stint in Colorado, they were ready to put down roots at home and build a legacy. When the couple purchased their twenty-acre parcel near Rosholt, they were unaware of the fact that it was twenty acres of sandy loam soil with south-facing slopes. It was the perfect geographical setup for a vineyard, which Jeremiah discovered while reading an article about fruit growing in the Midwest. They consulted other South Dakota winery owners and came to the conclusion that they had, in fact, found a diamond in the rough.

The Kleins decided to take a leap and open a winery. Although Jeremiah had experience farming traditional South Dakota crops, he was a grape novice. So, he went back to school, first taking chemistry courses at South

With the Wind Winery near Rosholt. *Courtesy of With the Wind Vineyard and Winery.*

Dakota State University and then enrolling in an online wine certification program through University of California–Davis. Additionally, a winery in Iowa took Jeremiah under its wing and showed him some of the practical applications of winemaking.

With the Wind Winery opened its doors to the public in June 2014. The house the Kleins originally planned to build transformed into the picturesque two-story farmhouse one sees today, with the tasting room and production area on the main floor and the family's living area upstairs.

Although it is a bit isolated to be part of a traditional wine trail (nearly two hours from the closest winery), many tourists traveling from North Dakota to the Sioux Falls area make a point to stop. Owing to that geographical isolation, With the Wind is unique to the area and, therefore, extremely popular with locals.

As of 2016, With the Wind was producing half a dozen different wines. The two flagship wines are the Expanse Fresh Red, a bright, semisweet red wine made from a blend of estate grapes, and the Expanse Crisp White, which is a blend of South Dakota–grown Edelweiss and Brianna, two of the

grapes developed by Elmer Swenson. With the Wind also produces a highly popular raspberry table wine that uses locally sourced fruit.

Between Jeremiah's work with production and Lisa using her marketing expertise to build the brand online and through social media, the first few years have been highly successful for the Kleins. They have already expanded their facility—a step they originally planned to take after five years.

SCHADÉ VINEYARD AND WINERY

Located just west of Volga in Brookings County is Schadé Vineyard and Winery. Volga's position nearly adjacent to Brookings, home of South Dakota State University, has been to the advantage of owners Jim and Nancy Schade. The school's strong agriculture department has been a great resource for winery interns studying small business, horticulture and vineyard management. Plus, the constant influx of visitors to the college town has kept the tasting room lively.

Before becoming full-time winemakers, Nancy worked for SDSU and Jim worked for the South Dakota Department of Revenue. They were also hobby winemakers. When the Farm Winery Bill passed in 1996, Jim resigned his position and obtained the state's third winery license, after Valiant Vineyards and Prairie Berry Winery.

The Schades were inspired to start a winery after a year living in Sacramento and enjoying Northern California's wine country. Since many South Dakotans will never make it to Napa Valley, they decided to replicate the experience the best they could on their Volga property. In 1999, Jim and Nancy planted their first vines, which were Valiant and Frontenac grapes.

Starting with a repertoire heavy on fruit wines, to cover some of the expense of planting a two-acre vineyard, Schadé quickly became known for a wide selection of consistently high-quality wine. The fruit wines include apple, black chokeberry, buffaloberry, raspberry-apple, strawberry-rhubarb and plum. Over time, the vineyard grew to more than one thousand vines, with the addition of Concord, St. Croix and Kay Gray grapes. As of 2016, the winery was selling more than five thousand cases, or 12,500 gallons, of wine annually. In an average year, the Schades harvest and purchase roughly seventy-five thousand pounds of grapes and fifteen thousand pounds of additional fruit.

Above: Jim Schade hauling grapes during the 2016 Schadé Vineyard and Winery Grape Stomp. *Courtesy of Denise DePaolo.*

Right: Schadé Vineyard and Winery owner Nancy Schade inspecting the vines. *Courtesy of Denise DePaolo.*

The Schades purchase fruit from more than twenty growers in South Dakota. The choice to use only produce sourced from within two hundred miles of the winery was an important part of the Schades' plan when opening their winery in 2000, with the only exception being cranberries shipped in from Wisconsin. Nancy explained that they endeavor to be "that authentic South Dakota winery."

Schadé received a value-added grant in 2014 to expand its line beyond wine to fruit juices, including elderberry and antioxidant-rich aronia, which is also known as black chokeberry. They are also producing brandy made from their Frontenac grapes.

Late each summer, Schadé hosts a grape stomp and harvest festival. At the event, guests can help with the harvest, earning free wine and juice for picking buckets of grapes. There is also live music, food vendors, wine tasting and, of course, the chance to turn one's feet purple.

Strawbale Winery

This winery's name evokes an image of pastoral simplicity: golden straw tidily stacked in a big red barn under a wide blue sky. Renner's Strawbale Winery is the realization of owners Don and Susie South's dream of country living, but the name denotes more than food for livestock. Straw is the material that insulates the winery and tasting room, keeping it snug in the cold and cool in the heat.

The Souths, both from Sioux Falls, started looking for property in the 1980s. Susie had taken horticulture classes, and they were keen on the idea of a second career in specialty agriculture. They considered starting an orchard but were fearful of a blight prevalent at the time. They thought about owning a Christmas tree farm, but that wasn't right, either. They even thought about growing asparagus, but as Don said, "There isn't anything particularly romantic about asparagus." Finally, they bought a bit of land over the border in Nebraska. Inspired by the home winemaking of Don's parents, the Souths planted a modest vineyard and began making wine as a hobby in the late 1990s.

Back in South Dakota in the early 2000s, the couple planted another half-acre vineyard on their six-and-a-half-acre Renner property and began selling commercially in 2006. Over time, they have switched focus from grape growing to winemaking. The Souths buy their grapes from four growers in

Owners Don and Susie South on the lawn of Strawbale Winery near Renner. *Courtesy of Denise DePaolo.*

Strawbale Winery's historic barn. *Courtesy of Denise DePaolo.*

Minnehaha County, where their winery is, and they source most of their fruit—aside from cranberries, of course—from within the state of South Dakota. Their half-acre vineyard, consisting of Frontenac and La Crescent grapes, produces some fruit but is largely for the benefit of winery guests.

Strawbale's location just north of the junction of Interstates 90 and 29 was a happy accident. When the Souths bought the property in 1992, having a commercial winery wasn't a possibility, but now it allows them to host weekly events that draw people from nearby Sioux Falls. They also get a lot of travelers visiting Sioux Falls or driving through. To his surprise, Don said, they get a lot of California winery owners curious about South Dakota's young industry.

Strawbale stays busy year round. The Souths host a harvest festival in early October. During the month of December, they offer Twilight Flights. Two or three people can partake in an evening of food and wine before a helicopter ride to view the holiday lights over the nearby city of Sioux Falls, including the waterfall and Winter Wonderland display at Falls Park.

The farm itself has a quirky history. The man who homesteaded there was named Alfred Anderson. He had been an orphan and lived a bachelor's life on his farm. However, he was a great friend to all the neighborhood

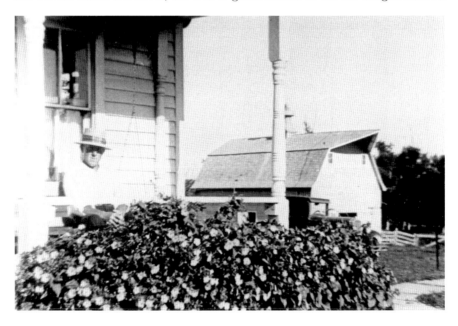

Farmer Alfred Anderson sits on his porch in the early twentieth century. He homesteaded the land where Strawbale Winery stands today. The barn, likely ordered from Sears and Roebuck, remains a picturesque feature of the property. *Courtesy of Strawbale Winery.*

children. He built seesaws and other equipment for them to play on, and he would allow them to have their birthday parties on his property. Susie explained that they still get visitors asking, "Was this Alf's place? I had my eighth birthday party here."

Alf's house has since been demolished, as it sat empty, decaying for years before the Souths took possession. In its place now stands a large, yellow, modern farmhouse that overlooks the winery, vines and sprawling yard, dotted with chickens. The big red barn that Alf ordered from a Sears catalogue remains, however, watching like a sentinel as the farm thrives in its new life.

TUCKER'S WALK VINEYARD AND FARM WINERY

Dave and Sue Greenlee wonder why they didn't start their vineyard and winery sooner. The couple met in high school in Sioux Falls and then reconnected in the 1990s while working as an environmental scientist and a mathematician at nearby EROS Data Center. They now use their STEM backgrounds to make delicious wine.

The Greenlees have very specific passions: wine, science (of course), Arabian horses and Afghan Hounds. The name Tucker's Walk is a reference to one of the couple's beloved Afghans. The winery's namesake is part of its branding, appearing mid-stride on its labels. After the grapes are harvested, one will see the horses lazily nibbling at plants among the vines, surrounded by a towering deer fence.

The fence encloses thirteen acres, six of which are planted with 3,500 vines of Brianna, La Crescent, St. Croix, St. Pepin, Marquette and Frontenac Gris grapes. Dave marvels at how, despite similar provenance, these grapes perform so differently year to year. He gives the example of Brianna versus La Crescent. The Brianna, "which is a joy to work with," has big grapes with tight, juicy clusters. Then there's La Crescent, "the problem child," which is a "crapshoot" year after year but has a light, citrusy taste and makes a good wine.

Likely the first South Dakotans to plant U of M's Marquette in their vineyard, the Greenlees' flagship wine is now made from these red grapes. Dave recalled acquiring the first three Marquette vines from Janesville, Minnesota's Winterhaven Vineyard and Nursery. He and Sue had never tasted the grape or wine made from it, but they had been assured that it

Tucker's Walk Vineyard owner Sue Greenlee peeks through the grapes. *Courtesy of Tucker's Walk Vineyard.*

Volunteers take a break from an early harvest. *Courtesy of Tucker's Walk Vineyard.*

was going to be a good thing. So, in 2006, the Greenlees brought their first Marquette vines back to Tucker's Walk in Dixie cups. The next year, those three were joined by five hundred more for a half acre of Marquette grapes.

In 2014, Tucker's Walk's Marquette earned Silver at the Finger Lakes Wine Competition in Upstate New York and sold out at the tasting room. Dave loves the good acid and tannin levels the grape shows. It makes for great wines when fermented to dry. Like its grandfather Pinot Noir, Marquette is a bit of a selfish grape—it doesn't like to be blended with others. This is why the Greenlees and other South Dakota vintners, like Mike Gould of Firehouse Wine Cellars and the Jacksons of Belle Joli', make 100 percent Marquette wines with no other grapes blended. Marquette also likes some time in contact with oak, but this contact seems best when limited so as not to override the berry, cherry, earth and spice characteristics the wine naturally shows.

Dave's son, Chet, is the third generation to make wine. To the Greenlees, it is a passion, but one tempered by caution. The winery's slow growth can be attributed to the desire for a balanced life, as well as the intention to be fiscally responsible. Unlike many winemakers who jump without a net, Dave and Sue have managed to build their modest empire with no debt.

WILDE PRAIRIE WINERY

While many South Dakota wineries infuse their Marquette with oak spirals, Victoria and Jeff Wilde have begun oak barrel aging. The couple owns Brandon's Wilde Prairie Winery, located off I-90, just fifteen miles east of the I-29 junction. The tidy row of barrels sits in the basement of the farm winery's historic barn, where the winemaking takes place. The barn's main space houses Wilde Prairie's tasting room and retail space.

Jeff, a South Dakota native, met Victoria while living in her home state of California. She had a dream of planting grapes on the small property the couple owned in the Golden State, having taken a grape growing and winemaking course in college, but it wasn't until they moved to South Dakota that Victoria got her vineyard. In addition to grapes, first planted in 1997, the Wildes raise cattle and alfalfa.

Victoria began as a hobby winemaker in the basement of the farmhouse, but she soon decided that she wanted to do more and sought a commercial license. Hay and old equipment were cleaned out of the barn, new floors

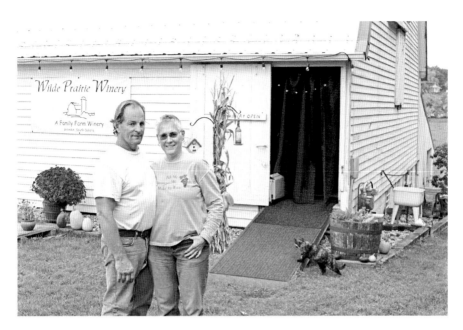

Wilde Prairie Winery owners Jeff and Victoria Wilde. *Courtesy of Denise DePaolo.*

Wilde Prairie ages Marquette in oak barrels. *Courtesy of Denise DePaolo.*

and drains were installed in the lower level and the space became the heart of Wilde Prairie's operation.

The first wines sold under the Wilde Prairie label were a rhubarb and another made from Valiant grapes, called Prairie Red. Prairie Red is described as "fun and fruity," pairing well with red meats and rich sauces. Over the years, Wilde Prairie's repertoire has grown to more than a dozen varieties. Playful blends like Honey Raspberry and the sweet red Christmas Cheer reflect Victoria's artistic sensibility.

All of the fruit used in Wilde Prairie's wines is South Dakota grown, without exception. The Wildes grow fruits (like cherries, blackberries and rhubarb) in addition to six grape varieties in their three-acre vineyard (four cold-hardy reds and two whites). One of Wilde Prairie's most successful grapes has been Frontenac. Victoria explained that it can be made dry, semisweet or sweet and can present flavors of pepper, chocolate and black currant.

Victoria hopes that South Dakota wines will soon receive the respect and recognition they deserve. Although the flavor profiles are different from the wines she first made in California, she pointed out that wines made from cold-hardy grapes and local fruit are winning awards, and that is evidence that things are headed in the right direction.

COBBLING A TRAIL TOGETHER

South Dakota's current winemakers hope that new colleagues will join their ranks along the I-29 corridor, making it possible for wine lovers to plan full vacations spanning the state from border to border. Hobby winemakers are turning pro all the time in South Dakota, and the more farm wineries that pop up, the easier it will be for tourists and locals alike to plan a day of sipping and sightseeing.

As of 2016, one could do that with ease in the Sioux Falls area, with half a dozen wineries within a thirty-minute drive of the city. And in the west, those staying in the Rapid City area can enjoy several wineries within an hour's drive. As far as the rest of South Dakota's 77,184 miles, therein lies nothing but possibilities.

Chapter 7
WINE IN THEM THERE HILLS

IN THE SHADOW OF THE SHRINE

In the shadow of Mount Rushmore, Mike Hackett holds a thin-stemmed glass of ruby-red wine. Sometimes he can't believe he lives here, so close to the Shrine of Democracy. This is quite a place to retire.

Hackett was enjoying this amazing view in 2004, after retiring to the area, when the landscape started to change. Not the actual view of the countryside, but the landscape of the brand-new industry getting ready to burst wide open in the Black Hills. The new Prairie Berry Winery tasting room and production facility had opened its doors just miles away from his new home. A boost was given to the tourism industry in the area, and a whole new trade was born there: the wine industry.

Mike Hackett, who has made himself into the Black Hills wine expert after working at three of the area tasting rooms—Prairie Berry, Naked Winery and Firehouse Wine Cellars—has been here from the beginning. He was an early Prairie Berry manager, helping to hire and train associates to share wine experiences with guests. His wine background came from living in Northern California for more than thirty years and setting up wine clubs there. Hackett has a unique perspective on Black Hills wine from watching it evolve over the past decade. His great pride in the area is evident.

He recalled the early days when people would come into the tasting room at Prairie Berry looking like "deer in the headlights" about wine and the

wine culture. Today, locals and tourists alike come into the wineries of the Black Hills with high expectations, and they leave impressed. Customers now are more knowledgeable about wine and more comfortable with the lifestyle. Hackett claimed, "It's really been an educational experience for people that has allowed them to more fully enjoy and appreciate wine." This enthusiasm and knowledge has rubbed off on other businesses in the area, not just the wineries themselves. Restaurants have better wine selections and higher-quality food with which to pair these wines. Even a detail that seems as simple as serving wine in varietal-specific glassware from companies like Riedel would have been unheard of ten years ago; however, it is commonplace today.

Hackett has witnessed the Black Hills get 100 percent behind this industry. The largest reason is because of the use of those all-important hybrid grapes South Dakota and other midwestern growers love. After several years of growing and making wine from native fruit, producers have gotten better and better at creating wines from the vines that have proven to do well in the Black Hills of South Dakota.

MARQUETTE

Marquette is the grape on everyone's mind on the western side of the state—and the eastern side, too, for that matter. Marquette was developed by the University of Minnesota, one of the literally hundreds of grape varieties the school has created since the 1970s. U of M released the vines for commercial sale in 2006.

Marquette is a blue-skinned red grape that resists many types of rot, mildew and disease and can grow in winter climates where the temperatures reach the tens and twenties below zero. The high sugars, moderate acidity and strong tannins are the traits that allow the fruit to make good wine. Since it is the grandson of the French Pinot Noir grape, it tends to produce medium-bodied, ruby-colored wines with cherry, berry, pepper, spice and earth characteristics. It is often easy to tell these wines are related to Pinot Noir. In the past ten years of growing for commercial wine production, Marquette has pleased winemakers again and again.

Mike Gould at Old Folsom Vineyard has a great appreciation for Marquette. Gould's trust in the variety is so great that of his acreage, two-thirds of the plantings are red, and most of these red vines are Marquette.

He views this grape as the one that can make serious wines of substance and structure—even wines that can be aged in the cellar, depending on the harvest year and production techniques.

The American is Firehouse Wine Cellars' 100 percent Marquette grape wine. The name is a reference to Gould's grandfather Anton, who immigrated to the United States on a ship called the *American* and taught Mike to appreciate wine. The connection shown through the name of the wine is further proof of his conviction in the quality of this grape—it is not just any wine Gould would have named in honor of his grandpa.

When Matthew Jackson and his family started their experimental plot of vines in Belle Fourche, they tried growing Pinot Noir, among other common varieties; however, the grape was just too finicky to grow well in the cold Black Hills climate. Jackson knew that he wanted to make a dry red wine, though, and began looking for a grape that would help him meet his goal. Soon, Marquette arrived on the market, and Matthew saw much potential in this relative of Pinot Noir. Today, he grows five acres and excitedly states that Marquette "is going to be an amazing grape for wine." Belle Joli' makes a 100 percent Marquette wine that sells out every vintage.

La Crescent

As an enologist, Matthew Jackson has other wine grapes for which he sees great possibilities for growing in the Black Hills. He and his brother tried to cultivate Riesling vines in their experimental plot, but although the vines lived a while, they could not survive the brutal winters and short summer growing seasons. The Riesling vines soon died. That left the Jacksons searching for an equivalent wine grape from which to make white wines and for other future projects at Belle Joli'. Matthew found the La Crescent grape, another University of Minnesota hybrid, released in 2002.

La Crescent is extremely cold hardy, surviving to thirty degrees below zero or colder, making it able to live where Riesling could not. With both high sugar and high acid content, these grapes can make wines from dry to sweet and everything in between. Common aromas and flavors are peach, apricot and pineapple, with citrus and other tropical fruits. It makes a wonderfully citrusy wine that Dave Greenlee professes is a perfect pairing for South Dakota walleye.

Frontenac—Noir, Gris and Blanc

Yet another U of M grape that Matthew Jackson experimented with in that small Belle Fourche plot was Frontenac. Frontenac Noir is a red grape that is cold hardy to more than thirty degrees below zero and is very disease and mildew resistant. It became very popular in Minnesota and surrounding Midwest states after its release in 1996.

Like the Pinot grape, Frontenac spontaneously goes through mutations to create other colored grapes in the family. Frontenac Gris is the gray version of the grape, Frontenac Blanc is the white version and Frontenac Noir is the black; many growers have success with all three in the vineyard. Frontenac Noir is blue- and black-skinned, with a dark-colored pulp inside. Most dark-skinned grapes still have white pulp, but Frontenac Noir is unique. This inner color makes wines that can be deep red or even lighter, rosé shades of pink, depending on production techniques. Because of its high acid and sugar, it can also make very diverse styles of wines, anything from sweet to dry or rosé to port.

Frontenac Blanc is not yet being widely grown, but Bob Weyrich—South Dakota Department of Agriculture ag development representative—sees it

Frontenac grapes after harvest. *Courtesy of Denise DePaolo.*

as a very promising grape for the area. Weyrich has been involved in the South Dakota wine industry on multiple levels for more than ten years, mostly on the agricultural side. He likes Frontenac Blanc and hopes to see growers increasing their interest in this vine. The vines survive the intense Black Hills weather, and birds don't cause as much destruction to these vines. Because the grapes on the vines are blanc, or white, they are not as easy for the birds to see, so these pests tend to leave them alone more than other grapes. Frontenac Blanc has the ability to make great wines, especially once the acid level settles. Weyrich truly believes that Frontenac Blanc can be a "regional wine to show what South Dakota can grow."

Frontenac Gris also grows well in the harsh Black Hills environment. Matthew Jackson had this as yet another of the experimental grapes in the Jackson family's original plot. It continues to grow well for him and other producers. Frontenac Gris shows the same resilient characteristics of the Frontenac "siblings," such as extreme resistance to rot and mold; these vines also survive the punishing South Dakota winters. Wines from Frontenac Gris are generally off-dry to sweet due to the high sugar (called brix in grapes) content of the ripened fruit. Aromatic wines with peach, apricot and pineapple are common from this gray version.

BRIANNA

Brianna is a beautiful name for a grape with great possibilities for beautiful Black Hills wine. Bob Weyrich sees such possibilities for this green-gold grape. Another Elmer Swenson hybrid grape, it tends to have less vigor than some other hybrids. However, Weyrich likes the crop when it is harvested at lower brix (less sugar) and higher acid—all reasons to pick earlier. When "well balanced," it makes a light, fruity and clean wine, one that shows the true character of the grapes. If the grapes are left too long on the vine or if the grapes are over-cropped while growing, the "full expression of flavor" is often lost.

A ripe Brianna grape in the vineyard. *Courtesy of Denise DePaolo.*

Bob also sees Brianna as a grape to lure new wine drinkers to the world of wine due to its pleasant, off-dry fruit characteristics, often with pineapple and tropical fruits. Brianna is a *Vitis riparia* cross, a hybrid that was created by crossing grapes native to the United States. "It really represents the unique heritage of the region, and with additional experiences with growing and winemaking, it could be a favorite as a door-opener and a staple for most wineries."

PETITE PEARL

The newest grape Black Hills growers look forward to cultivating for wine is Petite Pearl. Yet another hybrid grape, Petite Pearl was created by Tom Plocher, a private viticulturist who learned much from his mentor, Elmer Swenson. The grapes grow in "wonderful little clusters" on vines that are extremely cold hardy, to thirty degrees or more below zero, and disease resistant to rots and mildews. This shows how stubborn and hardy these plants tend to be. Experimental plots have been growing since 2008. The

Young Petite Pearl vines, not yet ready for harvesting of fruit, at Old Folsom Vineyard. *Courtesy of Kara Sweet.*

Goulds planted their vines at Old Folsom Vineyard in 2014 and 2015 and will harvest for commercial wine production for the first time from the 2017 harvest.

Because the vines are fairly new on the market, wines made from the variety are still few and far between. However, these grapes have a lower acid level when compared to some other hybrids, leading to good wine. Dark garnet in color, wines from Petite Pearl have complex flavors and aromas while being balanced, making it a good grape for blending with other varieties. The grape is of such quality that it can also be made into single-varietal wines of 100 percent Petite Pearl. Gould—who has about two hundred vines—said that wines from Petite Pearl will "be superb…as good as Marquette," with a strong tannin structure. He looks forward to his next vintage and the first bottling of a Firehouse Petite Pearl wine.

ALL THAT SPARKLES

Gold miners trudged their way through the tangle of bushes to the chilly streams of the Black Hills. This wasn't necessarily dangerous work, but it was risky and unsure. Nothing was guaranteed. They were forced to make do, to innovate, to work hard. Today's Black Hills winemakers started in the face of this same adversity.

This pioneering spirit has always been a part of the Black Hills, and modern winemakers have it. They don't have this spirit only because they grow grapes and make wine in an unusual setting. It's even more than that. These producers are using techniques that are not only distinctive to South Dakota but are also methods not common in the industry as a whole. The Black Hills truly shows its innovative self through winemaking.

Matthew Jackson—the only full-time winemaker in the state with a bachelor's degree in enology—uses the promising hybrid grapes in Belle Joli's still wines; however, he uses them in totally unique and innovative ways, as well. His techniques are not being done anywhere else in the state or region. He has pushed the boundaries far beyond just making great wine from a place known more for its outdoor activities and rock carvings than its hand-crafted beverages.

Matthew makes sparkling wine in the traditional method, also called methode traditionelle or methode champenoise. Yes, he is making wines in the traditional method of the most prestigious sparkling wine area of

the world, the Champagne region of France. This is a complex and time-consuming process, but one that grapes grown in the Black Hills were almost meant to do.

Champagne, the region in France, is quite northerly in the country. What that means in wine-growing terms is that it is cold there. Springs start late; winters come early. The growing season is shorter and not nearly as hot as other regions farther south. This climate produces grapes higher in acid and lower in sugar. In turn, this style of fruit makes base, still wines of strong acid structure before becoming sparkling wines.

Matthew knew early that his Black Hills climate was very similar to the northerly Champagne climate. He also knew that he wanted Belle Joli' to produce traditional-style sparkling wines from hybrid grapes. There were just too many similarities between the areas. At Fresno State, he studied sparkling wines and learned more about the process and the grapes to use. He and his wife, Choi, even spent time in Champagne after a formal invitation to a Champagne leadership conference.

His Estate Brut sparkling is made from the La Crescent grapes Matthew respects. The high acid content gives the much-needed backbone to the still wine—the first step in making methode champenoise sparkling wine. The

Choi, Matthew, Patty and John Jackson at the groundbreaking of Belle Joli's sparkling house in Sturgis. *Courtesy of Kara Sweet.*

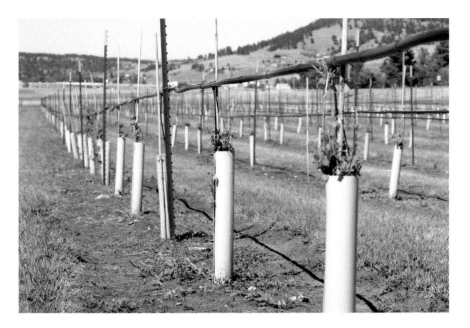

The vineyard of Frontenac Noir grapes in front of Belle Joli's sparkling house in Sturgis. *Courtesy of Kara Sweet.*

still wine is produced and bottled just like normal, except for the style of the bottle used. Still wines are put in "champagne" bottles with thicker glass, which makes the bottle stronger to withstand the pressure of the bubbles that will soon be produced within.

Once in this special bottle, a mixture of sugar and more yeast is added to stimulate a second fermentation. Carbon dioxide is a byproduct of all fermentation, and when the second fermentation happens in the bottle, there is no place for the carbon dioxide to go. The gas is absorbed into the still wine, creating the bubbles for the sparkling. The yeast that creates fermentation is still in the bottle, so it needs to be removed. Conventionally, the bottles would be "riddled," meaning that periodically they are spun and rotated to eventually be almost upside down so the spent yeast—known as lees—would be in the neck of the bottle. To remove the yeast, the neck is immersed in freezing brine to solidify the yeast in the bottle, and then the frozen yeast-cicle is popped out of the bottle before adding the dosage, a final bit of sweetness. As quickly as possible, the cork and cork cage are placed on the top of the bottle.

Jackson uses all these steps, but modern technology has given him help in the process. The yeast he uses is naturally encapsulated, so when he riddles

the bottles to get the yeast in the neck for freezing to remove, it takes a little less time and effort. He still must turn the bottles upside down to freeze the yeast before popping out the frozen yeast-cicle, but it is a much faster process. When Jackson pulls this frozen yeast, it can be quite a messy process, with wine spewing everywhere. That is why the new Belle Joli' Sparkling House outside Sturgis has a special production room for such work. The final product is a wonderfully dry sparkling wine with tart citrus and bread dough characteristics, very reminiscent of traditional Champagne.

The Jacksons have great plans for the future of their wines, both sparkling and still. Matthew currently produces his still wines at the Belle Fourche facility. His next dream is to build a gravity-fed production space on the hill just above the current Sparkling House at the mouth of Vanocker Canyon. All production would take place there, with gravity helping complete some steps of the winemaking process. Then, a naturally temperature- and humidity-controlled cave would be built into the hill underneath the new gravity-fed facility and next to the current Sparkling House. This is where the production and aging of the sparkling wines would take place, creating a true, innovative, one-of-a-kind Black Hills product steeped in worldly traditions

TRADITION

The can-do spirit of the pioneers who settled the state of South Dakota generations ago continues to be seen again and again, especially in the wine industry. This spirit paired with family traditions led Mike Gould to try yet another industrious idea with his Old Folsom grapes: a port-style wine called Tradition.

Traditional port is made only in the country of Portugal, where it gets its name. Ports are fortified wines produced in yet another labor-intensive process. First, a still wine is produced. Then a neutral grape spirit is added. This stops fermentation, usually leaving a very sweet wine, and increases the alcohol content, leaving a very high-alcohol wine. Gould explained that the original purpose of adding the neutral grape spirit was to keep wine from spoiling before long journeys across the seas on ships, where it was "subjected to heat, time and light" that would ruin the product. Alcohol acts as a preservative, so after fortification, wines could be shipped from Portugal to other countries, and the wine would stay drinkable the whole

timc because of the alcohol content. While on the ship for the voyage, the wines would be stored in oak casks. This barrel aging is the second aspect that makes a port so unique. Time in a barrel adds further dimensions of flavor. The longer in the barrel, the more oxidation takes place, creating a wine full of rich, baked fruit characteristics.

Firehouse uses the traditional solera system for aging ports in casks, inspired by the time port spent in barrels in a ship's hull. A solera is a barrel system for aging and blending fortified wines. The bottom layer of barrels is the oldest vintage of wine. The second layer on top of the bottom layer of barrels is a year younger, and the third layer is a year younger still. Wine is bottled through a process called fractional blending. Wine comes from the oldest, bottom layer of barrels, but only a certain "fraction" of wine is bottled; the rest is left in the bottom layer of barrels. The next layer is then fractionally blended into the bottom, oldest layer, and the third layer is then fractionally blended into the vintage a year older. "This allows all vintages to age in perpetuity and also gain in complexity" because each vintage year has some of the original vintage as part of the blend.

Tradition is Firehouse's port-style wine from its own solera system. The 2013 vintage of Old Folsom Vineyard's Marquette was the first wine used and

Marquette grapes beginning fermentation at Firehouse Wine Cellars to begin the making of Tradition port. *Courtesy of Kara Sweet.*

added to the solera. In 2014 and 2015, the next vintages of Marquette were added. Part of the fifty-fifty blend of these two fortified wines was bottled in early 2016 for sale as Year One. After the 2016 harvest, the youngest vintage of Marquette was blended into Tradition. A fraction of this three-year blend will be bottled in 2017, as Year Two, to continue the cycle. Gould explained that the fractional blend means that "years from now, our future vintages will always have a fractional amount of the 2013 Marquette vintage."

After the port is fortified and blended, Tradition is aged in a "hybrid barrel" that uses both new American and new French oak staves, giving the best of both oak worlds to the port. The French oak adds an additional sweetness to the already-sweet dessert wine. American oak adds the aromas and tastes of vanilla. Both add another level of complexity to the traditional Tradition. Currently, the neutral spirit Firehouse uses to fortify Tradition is produced out of state. However, fellow South Dakota wine pioneer Eldon Nygaard is now making a neutral spirit from hybrid grapes that may be a source for fortification of Tradition in the future.

Gould's level of appreciation for the beverage is shown when he recalled the story of George Plantagenet, the Duke of Clarence. It is said that after Plantagenet was convicted of treason, he was given a choice of how to die. Plantagenet's choice? To be drowned in a butt, roughly 105 gallons, of Malmsey Madeira (another fortified wine aged in a solera system like port). Gould exclaimed, "I always thought that was a bunch of hooey until I tasted the stuff, and I now think he was on to something." Not that Gould is choosing this for himself, but he is incredibly proud of Tradition. The locally grown Marquette grapes produced and aged in the old-fashioned way of Portugal seems completely natural for Firehouse. It continues to show the tradition of South Dakota and of Mike Gould's grape growing ideals, something that Gould does indeed take very seriously. He wants to "see the tradition [of both port making and grape growing] last long after I'm gone."

Chapter 8

TAKING CARE OF BUSINESS

TWENTY YEARS IN THE MAKING

It has been more than twenty years since Eldon Nygaard worked to pass the Farm Wineries legislation making it legal to produce wine as a commercial venture in the state of South Dakota. Although few actual changes have been made in regards to that law, the industry itself has changed greatly, mostly in the sense of how much it has grown. After Valiant Vineyards was "winery number one," many others have been added to the roster. At last count, thirty winery licenses have been issued in the state; twenty of those are considered active producers. Other licenses may be dormant or are still in development. East River has a larger number of active farm wineries, mostly due to the friendly growing conditions for vines. No matter the number of licenses, there is one statistic that cannot go unnoticed: in twenty years, more than 2.7 million bottles of wine have been produced in South Dakota.

There has been quite a surge in wine producers in the past ten years, but this production follows a common cycle witnessed in many neighboring states. Although overall production is continually growing, the volume of wine produced tends to increase for several years and then hit a short plateau. At that point, both the number of wineries and volume increase before hitting a second plateau. This continues over time but equals slow and steady overall growth. Minnesota saw this after its first twenty to twenty-five licenses, too. This pattern follows the total increase in sales, volume and exports of wine in the entire country.

The gentleman who tracks this information for the state is Bob Weyrich, a self-proclaimed "champion" of the state's wine industry. He remembered always enjoying fine wine—even before he was legal. He also had an inclination for good food. These interests probably started in high school, when Weyrich worked as a dishwasher, and continued as he worked food service jobs throughout college. Weyrich has also been a farmer all his life. Put these together and add a trip to Napa Valley in 1983—when Napa was still more of a farm community—and the perfect resource for South Dakota wine was created.

According to the South Dakota Department of Agriculture, Weyrich's official job description as the Western South Dakota ag development representative reads, "Assists the state's producers in identifying and developing appropriate opportunities for South Dakota. Emphasis is placed on value enhanced opportunities for the state's agricultural products, both raw and partially processed. The scope can include manufacturing of food, fiber, forestry, feed or livestock utilization of products. Assistance can be in the form of technical assistance, business plans, pre-feasibility studies or financial reviews."

Weyrich has challenged himself to know wine better than ever before, all in an attempt to help promote South Dakota products. He tries to enjoy wine as much as he can, and trips across the state are supplemented with his personal travel to regions all around the country, such as Napa Valley, Sonoma Valley and Willamette Valley. To Bob, "It's all about the senses… the look, smell, taste, and savor" of wine. It is important to pick out all the components, to understand wine as a whole and then use this information to evaluate wines. This is then applied to his job of supporting South Dakota agriculture through wine.

Weyrich has worked with the industry for more than ten years. He consulted with and even worked for wineries—he was employed at Prairie Berry Winery for more than three years. One of the first tasks Weyrich completed to support the wine trade was the creation of the Wine Pavilion at the South Dakota State Fair in 2006. That first year, between seven hundred and eight hundred tickets for tastings of state-made wines were sold; in 2016, about three thousand tastings were sold. That is quite a difference. This event is touted as an educational affair for the public to learn more about South Dakota wines. The exposure has been so great that South Dakota craft brewers are now included.

Mostly, Weyrich works with growers and winemakers to support growth in the budding industry. Keeping track of economic impacts is just one way

Above: An early wine tasting at the South Dakota State Fair Wine Pavilion. *Courtesy of Bob Weyrich.*

Left: The first South Dakota wine logo. *Courtesy of Bob Weyrich.*

to do this. In 2011, Wyrich completed the first extensive data compilation on the wine business in the state. Figures showed that every $1 of specialty crop grown for wine generated more than $7 of revenue for wineries. For every gallon of wine produced by these wineries, $15.05 was generated in the economy. The value of specialty crops used to make wine also grew steadily from $625,000 in 2008 to $724,040 in 2011. As of 2010, farm wineries paid $345,000 in excise taxes to the state and created seventy-seven full-time jobs. It was estimated that every one thousand gallons of wine produced equaled another winery job.

The "surge and plateau" pattern noticed over the past five years was clearly shown in 2015 when overall production was down after an all-time-high volume produced in 2014. Total growth of the industry is still up 17 percent, however, including market share, which is up 7 percent. This means that 7 percent of all wine sold in South Dakota is made in the state. Although wine is not recession proof, wines made in the state continue to perform well in sales.

A MAIN ATTRACTION

Firehouse Wine Cellars' tasting room manager, Michelle Pawelski, agreed that business is good. Firehouse Wine Cellars opened in April 2014 looking to fill a niche market of producing wines from traditional grape varieties in downtown Rapid City. According to Pawelski's data, growth has been seen at every level—in the tasting room, via wine club memberships, in retail sales and through distribution sales. From September 2015 to September 2016, total sales (in the tasting room and with retailers) were up 42 percent.

Pawelski attributed this surge in sales to a multitude of factors. First, people in general are drinking more wine. Firehouse Wine Cellars' use of more traditional grape varieties fits this market. Next, the Black Hills is a very popular tourist destination, especially for midwestern travelers. As more wineries pop up all over the region and country, more tourists want to enjoy wines while on vacation. In fact, travelers are even coming to the area for wine alone and then seeing the usual attractions after wine. The already-established Firehouse Brewery next door—housed in Rapid City's original 1915 fire hall—has also been a benefit to attracting customers. The brewery has been in business for twenty-five years, creating a familiarity with the brand before the winery even opened. Finally, the demand for quality local food, wine and beer is a continuing trend. This is shown in the out-of-area visitors to the winery but also in the locals, who like the on-site production facility and use of some local grapes.

Although Firehouse Wine Cellars has a unique situation, its results are actually very similar to other wineries around the state. Matthew and Choi Jackson at Belle Joli' echo Pawelski's ideas about progress. Belle Joli' saw a growth of 30 percent in 2015 alone. The winery has a capacity of ten thousand cases, and as of now, all of this wine can easily be sold, often before the next vintage year is ready for customers.

The historic fire hall on Main Street in Rapid City, currently the home of Firehouse Brewery and neighbor of Firehouse Wine Cellars. *Courtesy of Firehouse Wine Cellars.*

This development of the wine industry as a boon to the tourist economy is noticed by local tourist associations as well. Ara Baumstarck, who promotes tourism on the western side of the state through Black Hills and Badlands Tourism Association, sees this often. Although the hard data of economic impact is difficult to pinpoint, she sees the increase in wineries all over the state as proof of growth. Part of her job is to visit various wineries and other attractions. When Ara stops at wine destinations, they are always packed. She also sees wineries becoming destinations, the main reason people come to the area.

Wine is a popular drink for moms, and most vacations are booked by moms. Add the developing beer industry throughout the state, and there is an added attraction for dads, too. Ara claimed this as a win-win situation since the region is already a family-friendly destination. At the visitors' center gift shop in Rapid City, there has been an obvious increase in the sale of South Dakota wines, the only wines licensed for sale there. Baumstarck

also sees the increase of multiple South Dakota Made stores—those that feature the state's wine, beer and food products—as clear anecdotal proof of the health of the industry.

East River, not only are there more wineries, but these wineries are also much closer in distance to one another, making it easier to visit more than one in a day, if desired. This has made the I-29 corridor a serious contender as a "wine trail," a destination opportunity for those who want to visit multiple wineries in a short period of time. Possibilities then arise for hotel deals, restaurant expansions and transportation services—yet more economic impacts from the wine trade.

BUILDING THE BRAND

The business of selling wine can be difficult, especially in a competitive market. South Dakota is a very unique atmosphere. The wine market is not flooded, but wine competes with other craft beverages—all industries that are booming throughout the state. Building a brand and a following becomes very important to stay viable all year long, not just during the busy tourist season of the summer. Rob and Kim Livingston are a great example of building a one-of-a-kind brand in order to differentiate themselves in the ever-growing Mount Rushmore State wine trade.

In 2011, the Livingstons and a small group of partners opened up a Naked Winery tasting room in Custer. They had done their homework through an early study that showed that the Black Hills could still sustain other wineries in addition to the two that already called Highway 16 home: Stone Faces Winery and Prairie Berry Winery. The Livingstons had been eyeing some type of a wine business in the region. They wanted to open something in the Black Hills, the area where they had built a successful construction business (also the area where they truly enjoyed living). They sought a winery partner, looking for a way to break into the industry with limited time and resource investment.

Naked Winery was an established producer from Oregon looking to expand. Rob and Kim were fun-loving folks, and Naked's gregarious brand seemed to be a perfect fit. After the Custer tasting room was opened, a Hill City tasting room came shortly after. Growth has been steady over the past five years, with sales and wine club memberships increasing annually. Customer growth and sales growth have been so continuous that the Custer

tasting room is moving into a larger space that will be opened by the summer of 2017, and a summer-only tasting room opened in 2016 in tourist-friendly Keystone. Naked Winery now makes some of its own wines at the Hill City facility from midwestern grapes. The Hill City space also houses Sick and Twisted Brewery, the Livingstons' South Dakota craft beer brand. An event space was also opened in back of the Hill City tasting room before the summer of 2016.

The Livingstons owe much of their success to their ability to differentiate themselves from the other South Dakota wineries, creating greater variety for consumers. The wines are traditional style from traditional varieties that will not grow in the cold South Dakota climate. However, it is the nontraditional atmosphere of Naked that warms customers' hearts and keeps them coming back.

Having the name Naked is no accident. It is the signal that Naked Winery will "take the pecksniffery" out of a product that is often seen as intimidating, especially in an area with a young industry like South Dakota. The double entendres on both the front and back labels definitely show that this winery does not mean business—it means fun. With wine names such as Missionary and Foreplay and descriptions that make people smile (or blush), an experience is created with each tasting and glass. It is a way to promote the idea that people should enjoy one another. Rob Livingston said that couples should put down their phones, turn off their televisions and pour their favorite Naked wines.

EVENTFUL HOSPITALITY

Differentiation of products within the state is just one way to build loyalty. Another very important way is through events hosted by or at the wineries. This helps build the brand and the business, all while making locals faithful to area wineries. The tourist traffic is a great boost to all South Dakota businesses, but in the other eight months of the year, wineries need to have locals who frequent the establishments. In true South Dakota fashion, the pioneering producers have given great reasons for guests to flock to the state's wine events.

Naked Winery's events include comedy shows, variety shows, murder mystery dinners and medieval dinners. From October until May, the Livingstons host two events a month. This is common in wineries throughout

the state. They host events in the winter months for their locals, building a customer base that will enjoy South Dakota wine all year. Firehouse Wine Cellars has its Vinote Sessions of live music every weekend throughout the year. Firehouse's biggest event is the annual Christmas party with a Christmas movie theme. *A Christmas Story* was the inspiration for 2015, while *How the Grinch Stole Christmas* was the 2016 theme. Belle Joli' holds oyster and sparkling pairings featuring its South Dakota sparkling wines. The winery also hosts Sunday brunches all year, featuring, of course, mimosas made with Belle Joli' bubbles.

The state's wineries celebrate their agricultural heritage with each bountiful crop. Schadé Winery holds an annual Harvest Festival and Grape Stomp early in September. With the Wind has its own festival to commemorate each autumn with its Grape Stomp Festival. Valiant Vineyards holds the Great Dakota Wine Fest to end each summer. This is a gala filled with local wine and food, including cooking demonstrations and an amateur winemaking competition. Firehouse Wine Cellars holds its Harvest Party in Old Folsom Vineyard and allows wine club members to finish picking grapes off the vines.

Firehouse Wine Cellars' harvest party in Old Folsom Vineyard, with James Van Nuys performing for wine club members. *Courtesy of Kara Sweet.*

Strawbale Winery has two very unique festivities. The summertime Folk Off and Rib Challenge is a food and music celebration that features local artists, barbecue masters and interesting vendors during a folk music competition. Strawbale's winter Twilight Flights could be the most adventurous way to build a customer base. To begin the evening, hors d'oeuvres and wine are enjoyed at the winery. Then a helicopter takes participants to and over downtown Sioux Falls to view the lights of the city and Falls Park in its winter beauty. Then the flight returns to Strawbale for dessert and dessert wines. Clearly, building brand loyalty is key to South Dakota wine business success, and the state's wineries have found a way to do this well.

THE FUTURE

The good aspects of the industry have made steady growth possible within the state. When the initial Farm Wineries Bill was passed, it gave wineries the ability to self-distribute. This proved to be incredibly valuable to the industry. It meant that wineries could sell their own wine in a tasting room or at off-premise retail establishments, such as liquor stores, grocery stores or restaurants. Although distribution is a lot of work, self-distribution allowed wineries to control their own practices and save money by cutting out the middleman—the person wineries would have to pay just to truck the product somewhere else for sale. Dave Greenlee of Tucker's Walk positively stated, "The distributor thing is a big part of our story in South Dakota."

However, there was still a limitation to the Farm Wineries act. Initially, wineries could not ship wine directly to consumers, including consumers who lived within the state. That all changed in 2016 when the South Dakota legislature updated the law to allow direct-to-consumer shipping in the state. Shipping is also allowed to other states if individual wineries have followed specific state laws and filed necessary paperwork in every state where shipping is desired. It is a very complicated system, with many federal regulations followed by a patchwork of fifty other sets of laws, one set for each state. In addition to the fifty different laws to deal with in order to ship wine, payment to ship into each state is another difficulty facing producers.

South Dakota wine has worked to overcome some of the obstacles that may have been holding the industry back. However, there are a few growing pains that might be felt as time progresses. The first disadvantage to growth that Bob Weyrich sees is the fact that eventually, wineries may need to band

together to self-fund professional activity. For instance, a portion of taxes or an increase in taxes might someday be necessary to set up an entity with the sole purpose of promoting the wine of the state. Much like there are tourism associations whose job it is to bring visitors to the state, wine tourism associations may be crucial to bringing traffic to the state's wineries to drink the state's wines. These are common in many other wine destination locations. It may not be long before South Dakota has the need to follow suit.

The South Dakota Wine and Grape Growers Association may be able to fill a similar niche, but it first has its own goals. The association has been around for quite some time; however, even though the number of wineries in the state was growing, the number of members in the association had dwindled. Eldon Nygaard saw the need for the group to revitalize itself, and he enlisted Mitch Krebs to assist in the process. Krebs had worked in communications throughout the state, gaining experience with state government advocacy while getting to know many of the key players involved in the state's growing wine trade. Krebs applied for the part-time position of executive director of the organization and went to work attempting to increase membership.

The primary goal of the group is to work with the legislature to look at South Dakota wine laws—many that have been in place literally since Prohibition—that might need to be updated or changed for the "new" industry that continues to develop in the state. The Wine and Grape Growers Association updated its bylaws and mission statement while creating a set of goals to achieve. These objectives all deal with increasing the advocacy, promotion and unity of those in the wine business. This first step in unification is just one road that leads to a bright South Dakota wine future.

Other steps to continued progress will include dealing with common issues wineries all over the world experience: climate and sales. One pressing matter is the supply of grapes and other fruits needed to keep up with the amount of wine that can be sold. The fact is that local growers are barely keeping up with the amount of fruit needed to make the amount of wine producers can sell. Winemakers need more grapes. They continue to look for people to grow additional fruits to ferment. This supply faces other issues than just the need. Even when there are people growing fruit, Mother Nature can cause problems. In other words, even when a winemaker thinks there is plenty of fruit that vintage year, the weather may make that untrue. Extreme weather can make two hundred vines that might usually produce one thousand pounds of fruit produce nothing, a very sad but true reality. Sadder still because growing grapes is a lot of work.

Another concern dealing with this supply and demand problem is the mandate that all products have to be fermented in the state, meaning that bulk wine and other products from outside the state are not supposed to be allowed, even for blending purposes, unless a special affidavit is requested and received each year. Soon, the time will come when some clarification on this portion of the rule will need to be addressed. Some leniency when it comes to the South Dakota product requirement could actually help increase production quality and production volume while decreasing overall costs to wineries. Much like changes in the ability to ship, producers have faith that lawmakers will eventually see the need to help the industry evolve over time.

Another change Dave Greenlee would like to see is the capacity to sell wines at farmers' markets. Those who enjoy the locally grown and locally made products also like local wine; these are the same people who frequent farmers' markets. It is an untapped sales venue that could help business. Plus, wine sales at markets would still be promoting South Dakota and its agricultural products.

The agricultural lifestyle exhibited in friends and neighbors coming together for a branding. *Courtesy of Anna Miller Museum.*

Traditional agricultural values on display as friends and family help during Strawbale Winery's crush. *Courtesy of Strawbale Winery.*

Currently, farmers' markets would have to get permits after a public hearing from the city or county governing bodies where sales would take place. There is a fee for this license, which may be too expensive for nonprofit farmers' market groups. Another option would be for individual wineries to get temporary off-premise sales permits, again at the city or county level. Fees apply here also, and the costs required to get a permit for the market every week would quickly add up for wine producers. There is definitely a possible audience here that Greenlee would like to see become easier to tap.

Another tremendous burden that Bob Weyrich continues to see is the amount of work wine really is. Of course, this is an industry that is filled with romance and prestige—when viewed through the customer's eyes, anyway. A beautiful glass of wine with an amazing meal really is an example of the finer things in life, but those producing the wine know the truth: wine is an agricultural product, and that means work, lots of it. Many get involved in winemaking because they love the farming aspect: being outdoors, working with vines and enjoying the dirt. Others get involved because they love wine. No matter the reason, the workload remains the same.

Many of the state's wineries are small mom and pop operations where the same person is in charge of growing the grapes, harvesting the fruit, making the wine and selling the wine. This truly is too much for one individual to sustain for a long period of time. Yet the conundrum comes when not enough money is made to finance more people to help with all that work. It is often a catch-22 for small agricultural businesses, and wine is no exception.

But many continue to do this hard work and do it very well. During times of intense labor, volunteer troops of family and friends are brought in to help prune, harvest, bottle and sell. It may no longer be the old-fashioned barn raising or cattle branding of old, but it is the same premise. The farming and ranching belief of helping thy neighbor is still alive and well in the state. It is seen often in the vineyards and wineries, a new business based on old-fashioned farm values.

The Possibilities

Weyrich's main job might be to track the economic growth of the trade, but he has done a lot of tracking the evolution of quality in the trade at the same time. With every vintage year, he sees farmers learn more about their fruit. He sees the vines get a year older and produce higher-quality grapes. He sees winemakers learn more technical expertise. Most of all, Weyrich believes, "there are not really any barriers for the future right now." It is an industry that can take itself wherever it wants to go.

He looks for those in the industry to continue to improve the quality of wine as a natural progression. Winemakers will strive to make even more balanced wines that show both the art and science in making great beverages. This will happen naturally as the vines mature, but also as the consumers mature. Customers will continue to drive the need for better-quality wine, and data shows they will be willing to pay for it.

Matthew Jackson stated it best when he said that making wine is an all-encompassing undertaking. He appreciates the task, hard work and all. His patrons do, too. They continue to support the South Dakota industry at astounding rates. It's an industry for which Jackson can't wait to see what the future holds. His eyes twinkle as he speaks of his "love to see regions be themselves." That is what he sees for the state. He imagines it emerging as a unique growing region, one that is not merely a destination but perhaps appreciated with one or two separate American Viticultural Areas (AVAs)

within the state, a legal designation that distinguishes it from any other area in the country.

Dr. Anne Fennell of South Dakota State University also can't wait to see what the next twenty years will bring. She finds great interest in the current increase of wine consumption all over the country. In fact, producing wine from every state is what will eventually turn the population into a "nation of wine drinkers." Unlike the growing of corn or wheat, wineries provide places to enjoy local crops, places to visit that also add to the economy. Wineries provide jobs from agriculture-based products, just like South Dakota has been doing for generations. Wine contributes to this ag lifestyle, just in a different, more immediate way. There is an "immediate touch with the consumer…so people begin to think of it [local wine] as something of their own."

Chapter 9

DAKOTA WINE AND
FOOD PAIRING

D rinking good wine with good food in good company is one of life's most
civilized pleasures," said modern-day wine expert Michael Broadbent.
Perhaps no statement was ever more accurate. Wine is a special addition
to any meal. It can turn regular food into an occasion. In fact, wine turns
any normal day into an event. People all over know this and choose wines
accordingly.

In truth, no other beverage is as revered as wine. Consumers all around the
world don't ponder what the best soft drink is to enjoy with a meal. Before
friends come over, the hostess doesn't agonize over whether the iced tea will
go well with that evening's fare. Entire professions do not revolve around
pairing water with food. Only wine evokes these reactions. Only wine.

Wine is not only considered a part of any impressive meal, but it is also
meant to add to the meal. In fact, a great food and wine pairing brings out
the best of both the food and the wine. This is the goal. And it isn't just
modern consumers who view wine through this lens.

Traditional wine and food pairing stemmed from the fact that wines
made in Europe naturally complemented the common meals of each
distinct area. For instance, it is no coincidence that the Spanish coastal
region of Rias Baixas in Galicia makes wonderful white wines from the
Albariño grape, wines that happen to make a perfect partner to the
fresh seafood caught nearby. Farther inland in the same country, red
Tempranillo grapes grow in abundance, making wines that pair well with
the more robust lamb and beef meals there. Travel around the globe and

traditional wines from nearly every region pair with the historic staple foods in that same place.

Fast-forward hundreds of years, and modern-day wine and food pairing is a whole new world. Due to globalization, almost any food can be found in any region of the world. Want Spanish tapas? Go to a local restaurant with a tapas menu anywhere in the United States. No need to fly halfway around the world. It would be fun to pair a Spanish wine with this meal, but it might be even more adventurous to pair a wine from a hybrid grape with that European specialty. In today's wine and food scene, rules can be broken.

THE RULES

Many people will wax poetic and drone on and on while giving an extensive list of rules for pairing wine to food. However, wine and food pairing is not nearly as complicated as others make it if just a few simple guidelines are followed.

Before pairing, it is important to remember that wine is always paired to food. Keep the food in mind and then decide what wines would go well with it—not the other way around.

First, always pair wine to food based on the wine and food character. This is the texture and flavor intensity of the food. In other words, the "body" of the food. The character profile of a food like poached halibut would be very light; it is light in texture and flavor—overall light in body. On the other hand, the character profile of a food like a medium-rare, grilled beef ribeye steak would be heavy; it is heavy in texture and flavor—overall very full in body.

The general rule to follow is the lighter the character of the food, the lighter the character of wine that should be served with the food; the heavier the character of the food, the heavier the character of wine that should be served with the food. A nice, light-bodied Sauvignon Blanc or La Crescent would pair very well with that poached halibut. A full-bodied Cabernet Sauvignon or Marquette would be perfect served with that medium-rare ribeye.

Second, pair wine to food based on the chemistry of both food and wine. Chemistry refers to the flavors inherent in food. Food has four basic flavors: sweet, sour, bitter and salty. (There is an argument for umami, but for food and wine pairing, these four work.) Wine has four basic flavors: sweet, acidic,

tannic and mineral. Each of these tastes match one of the food tastes: sweet in wine to sweet in food, acidic in wine to sour in food, tannic in wine to bitter in food and mineral in wine to salty in food. When matching like flavors, it is called a complement pairing—similar flavors go together. In specific terms, a sweet fruit wine would go with a sweet dessert. The sweet to sweet complement each other.

There is also the contrast pairing; this is when opposite tastes are paired together to accentuate the best in both food and wine. In contrast pairings, a sweeter wine could be paired with salty or sour foods and a mineral wine could be paired with sour or bitter food. In specific terms, that same sweet fruit wine would pair well with ham, a salty food.

One last way to use chemistry in pairing is to use the marriage pairing: wine is used in the preparation of the food and then paired with the food when eaten. The traditional beef bourguignon uses wine in the recipe. If this same wine is paired with the meal, a natural match is created.

Third, it is important to remember that cooking technique changes the characteristics of food, thus changing how wine should be paired with the food. For example, the cooking technique of poaching changes the chemistry and character of food very little. If poaching a piece of chicken, a lighter-style wine would be chosen. Sautéing and frying changes the character more, so a slightly heavier wine could be paired. Baking changes even more, and grilling and smoking changes the flavor and texture of food the most. Heavier-bodied and more tannic wines will complement grilled food better than poached food, so a red wine may pair well with grilled chicken or smoked turkey, even though those are white meats.

In addition to how the food is cooked, the seasoning and flavors added during cooking change the flavor profile of the food. Lightly seasoned and less flavorful food would be paired with a lighter wine. Add lots of spices and other flavors, sauces or gravies and the wine paired with the food can be heavier. Even if seafood—one of the lightest proteins—is being prepared, a lighter-bodied red may be appropriate, depending on the cooking technique of the fish, the flavors added or the sauces served.

There are some special reminders when pairing wine to food. Sparkling wines make great aperitifs since they are acidic, but they can also be paired with many foods. Brut and Brut Nature wines (very dry and acidic styles of sparkling wines) make better aperitifs, as very acidic wines are natural palate cleansers.

Dessert wines are too sweet for dinner; they overpower the taste of the food. A semisweet or off-dry wine, like many South Dakota fruit wines,

would contrast with salty or spicy, but this is a slightly sweet wine, not a dessert wine. Dessert wines—which are usually very high in both sugar and alcohol—should only be served with dessert, and a dessert wine needs to be just slightly sweeter than the dessert. If the wine is not sweeter, the sweet dessert may make the wine seem sour.

Ultimately, keep in mind that there is always personal preference when pairing wine with food. A favorite wine might always be a favorite pairing, no matter the food. However, pairing a new wine with food is the first step in expanding a palate to enjoy wines that may not be preferred yet. Trying different wines as part of a great pairing is the best way to learn more about wine and food.

With everything there is to know about wine and all the different wines available, there are times when some wines just should not be paired with food. If food is too hot or too spicy, it becomes impossible to pair with wine because the food will overpower the wine every time, no matter the wine. Really hot foods are too spicy for most wines and scream for a beer; luckily, South Dakota makes some great brews, too.

Another special pairing problem is wine that is too tannic, dry or astringent; this style will overpower most foods. Sometimes even grilled meat can't stand up to a young, very tannic wine. Luckily, South Dakota wines are incredibly approachable and rarely face this problem. If this does happen, though, just sip tannic wines by themselves without pairing to food. Using a wine aerator also helps soften the tannins and make a wine easier to pair. Letting a tannic wine cellar, or age for a period of time, also moderates the tannins to pair better with food.

The ultimate goal of a great pairing is to bring out and emphasize the best qualities in both the food and the wine. Neither should overpower the other. The wine flavor isn't lost; the food flavor isn't lost. The pairing doesn't overaccentuate one element of the wine to make the wine taste different, and the wine doesn't overaccentuate one element of the food either. A sure sign a pairing is great? There is no wine left in the glass at the end of the course.

The Food

Hors d'oeuvres and Cocktails

A great place to start every meal is with a South Dakota wine. South Dakota wines make the perfect style to begin a multicourse meal or enjoy a series of light bites as a meal itself. Many white grapes grow well in the state, like La Crescent and Brianna. Both of these grapes make lighter-bodied wines that pair well with lighter fare. Off-dry, fruit-based wines with a hint of sweetness make good wines to pair with hors d'oeuvres. Don't forget the state's sparkling wines as a starter, whether with food or just as an aperitif.

Belle Joli' Winery's Oysters on the Half Shell

12 fresh oysters on the half shell
fresh horseradish

1. Put oysters on a bed of ice.
2. Top alternating oysters with horseradish.
3. Serve immediately.

Pair with Belle Joli's Estate Brut Reserve, a crisp, dry sparkling wine made from La Crescent grapes grown outside Belle Fourche. The zippy wine is filled with hints of lemon and matches the brine of the oysters perfectly. The light-bodied wine is a perfect match for any seafood.

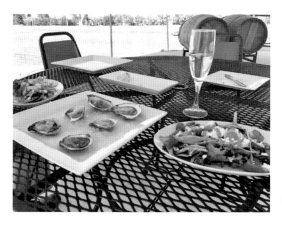

Oysters paired with South Dakota sparkling wine at Belle Joli' Winery. *Courtesy of Belle Joli' Winery.*

Belle Joli' Winery's Mimosas for Every Season

3 parts Belle Joli' sparkling wine—any style
I part fruit juice (orange for spring, watermelon for summer, peach for fall and
cranberry for winter)

In a sparkling wine glass or white wine glass, combine three parts sparkling wine with one part fruit juice, depending on the season.

For the driest mimosa, use the Estate Reserve Brut—the driest Belle Joli' sparkling. For a dry mimosa, use Vintage Brut. (Brut means a dry style of sparkling wine.) For sweeter mimosas, use Estate Reserve Demi Sec, Moscato Demi Sec or Pineapple Demi Sec. (Demi sec is a sweeter style of sparkling.)

Mimosas are wonderful for any season, any meal and any day of the week. Of course, special occasions scream for a mimosa, but so does a beautiful South Dakota Sunday with brunch. Relish the beauty of the state with a traditional method sparkling wine made in the Black Hills.

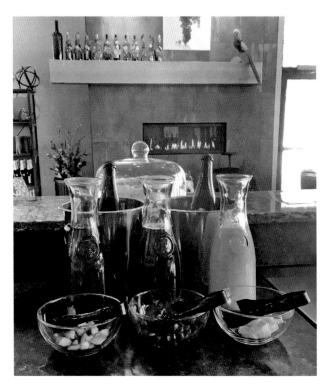

Mimosas made with Belle Joli's sparkling wines. *Courtesy of Belle Joli' Winery.*

Wilde Prairie Winery's Mulled Christmas Cheer

1 750ml bottle Wilde Prairie Winery Christmas Cheer wine
1 cup water
⅓ to ½ cup sugar or honey, depending on sweetness desired
3 tablespoons whole mulling spices (in a spice bag or large tea ball)
(optional suggestion if serving a crowd: add 1 quart 100 percent juice, like
cranberry, pomegranate, raspberry or grape, to the above wine mixture)

Combine all ingredients and simmer in a crock pot for 4–6 hours.

Quick method: Combine all ingredients in a small stock pot and bring to an almost boil, reduce heat and simmer for an hour. Remove spices before serving; they can go bitter if allowed to sit in the mulled wine for an extended period of time.

Christmas Cheer wine is a blend of the four red grapes grown in the Wilde Prairie vineyards: Frontenac, Valiant, Marechal Foch and Marquette. Mulled red wine makes for the perfect alternative to spiced cider during any holiday gathering.

Prairie Berry Winery's Black Currant Sangria

1 bottle Prairie Berry Lawrence Elk wine
2 cups orange juice
½ cup simple syrup
sliced limes, lemons and oranges
additional fresh fruit for garnish
orange zest
sugar

1. Mix the first four ingredients and chill for a few hours.
2. Dip the rim of a wine glass in orange or lemon juice and then in orange zest and sugar.
3. Add ice, fresh fruit, sangria and additional simple syrup to taste (recipe follows).

Simple Syrup

Mix equal parts sugar and water and boil until sugar dissolves. Allow to cool and then refrigerate.

This South Dakota–style sangria is a great summer beverage to enjoy with friends. The black currant wine makes the perfect base for this punch, and of course, enjoy the wonderful front label on the bottle of Lawrence Elk, inspired by Ralph Vojta.

Main Dishes

Although South Dakota produces many fruit wines, these wines are not just for appetizers and finger foods. Fruit wines and wines from hybrid grapes make very serious beverages that pair well with a multitude of main dishes, from light to robust. Using the wine as part of the meal is a special treat—called a marriage pairing—and leads to a perfect combination when the wine used in preparation is sipped with the food.

Strawbale Winery's Chokecherry Ribs

4 pounds baby back ribs
2 teaspoons sea salt
2 tablespoons garlic powder

1. Season ribs with salt and garlic powder and wrap in aluminum foil. Can start with frozen ribs and wrap them separately.
2. Bake wrapped ribs at 350 degrees Fahrenheit for one and a half hours before cutting open the foil. Brush with barbecue sauce (recipe follows) and leave the foil open. Put the ribs back in the oven for 10 minutes and let the meat rest for 10 minutes before serving.
3. If having a barbecue, cook the ribs ahead of time in the foil, and at the end of the first one and a half hours of cooking, leave them wrapped. The ribs can be cooked the day before. When dinnertime comes, take the ribs out of the foil, heat them on the grill and brush with the barbecue sauce. Grill for 10–15 minutes. Let rest for 10 minutes before serving.

Black Currant Barbecue Sauce

4 tablespoons olive oil
¾ cup black currant sauce (½ cup black currant jam with ¼ cup of water)
4 tablespoons soy sauce
2 chipotle peppers in adobo sauce
½ teaspoon freshly ground black pepper

Put all sauce ingredients in food processor and purée.

Serve with Strawbale's Black Currant Wine, a rich, full-bodied, semisweet wine with berry flavors that linger on the palate. The hearty food matches the wine and ends in a rewarding finish. Serve wine chilled or at room temperature.

With the Wind Vineyard and Winery Open-Faced Chicken Sandwich

2 slices gluten-free or regular bread, toasted
2 tablespoons goat cheese or cream cheese
1 thinly sliced, baked chicken breast
1 jar sun-dried tomatoes, in oil

1. Top toasted bread with room-temperature goat or cream cheese; spread evenly.
2. Add chicken breast slices.
3. Top with desired amount of sun-dried tomatoes and drizzle with oil from tomatoes.
4. Serve with a green salad.

Pair with With the Wind's Expanse Crisp White wine, an award-winning, light-bodied wine perfect for the light meal.

Firehouse Wine Cellars' Scallop Linguini

I pound linguine
I pound sea scallops
salt
pepper
I tablespoon olive oil
I tablespoon butter
I shallot, finely diced
I garlic clove, minced
½ cup Rushmore Riesling
½ cup clam juice
¼ teaspoon red pepper flakes
12 basil leaves, chopped
¼ cup parsley, chopped
I tablespoon chives, chopped
I tablespoon capers, drained
zest of I lemon
juice of ½ a lemon
I tablespoon butter

1. Bring a large pot of water to boiling. Add a generous amount of salt and cook linguine until al dente.
2. Season scallops with salt and pepper. Heat olive oil and butter in a large skillet over medium-high heat. Sear scallops for about two minutes on each side; remove from skillet to a plate and cover with foil. Set aside.
3. Add shallot and garlic to the same skillet and sauté until softened.
4. Add wine and cook until reduced to almost gone.
5. Add the clam juice and reduce by about half.
6. Add red pepper flakes, herbs, capers, lemon zest and lemon juice. Season with pepper to taste and add the butter.
7. Add the cooked and drained linguine to the skillet. Allow the liquid to be absorbed and the sauce to coat the pasta.
8. Transfer to a serving bowl and place the seared scallops on top.

The pasta dish pairs well with Firehouse Wine Cellars' Rushmore Riesling, a semisweet wine that brings out the sweet meat of the scallop and the herbed butter on the linguini. This is also a marriage pairing, with the wine used in the preparation of the food.

Schadé Vineyard and Winery's Pheasant and Wild Rice

12 ounces bulk pork sausage
1 large onion, finely chopped
8 ounces mushrooms, sliced
1 (8-ounce) can water chestnuts, drained and chopped
½ lemon
2 (6-ounce) packages wild rice mix
1 (10-ounce) can cream of mushroom soup
1 (10-ounce) can cream of celery soup
1¼ cups milk
1 teaspoon salt
½ teaspoon black pepper
2 cups chopped, cooked pheasant
½ cup toasted, slivered almonds
½ cup sliced almonds, for garnish on top

1. Brown the sausage in a skillet, stirring until crumbly; drain.
2. Sauté the onion and mushrooms in the skillet until tender.
3. Add the water chestnuts when the vegetables are almost tender.
4. Squeeze the lemon over the mushroom mixture.
5. Prepare the wild rice mix using the package directions.
6. Combine the mushroom soup, celery soup, milk, wild rice, salt, pepper, pheasant, sausage, mushroom mixture and toasted almonds in a large bowl. Mix well.
7. Pour into a 9x13 baking pan.
8. Garnish with the sliced almonds.
9. Bake at 350 degrees Fahrenheit for one hour.

Serve with a glass of Schadé's Chokecherry wine. The sweet of South Dakota's wild fruits and the savory of South Dakota's wild game are perfect companions. This is a great example of a contrast pairing.

Valiant Vineyards' Buffalo and Pheasant Roll

12-inch-long buffalo tenderloin
1 pheasant breast
1 egg
¼ cup whipping cream
8 dried morel mushrooms
dried sage
garlic salt
Montreal steak seasoning
butter

1. Begin with a 12-inch-long buffalo tenderloin, fillet it into ½ inch thick; it should end up being about 8 inches wide and 12 inches long.
2. Next take one pheasant breast and, with a fillet knife, remove the tendons that are typical in the breast.
3. Place the pheasant meat in a food processor. Add one egg and whipping cream and blend into a mousse.
4. Spread the mousse evenly over the buffalo tenderloin.
5. Rehydrate dried morel mushrooms (about 8 medium-sized) with tepid water. Cut in half and arrange on the pheasant mousse.
6. Use the morel water to pour over the buffalo before cooking.
7. Next sprinkle dried sage over the mousse.
8. Roll the buffalo up like a jelly roll and secure the roll with string.
9. Sprinkle the outside of the roll with garlic salt and Montreal steak seasoning. Spread butter on top of the roll after placing in a baking pan lined with foil.
10. Pour the morel water in the bottom of the pan and broil for 10–15 minutes, uncovered, to brown the meat.
11. Remove from the oven and wrap the foil over the meat to keep the flavor in—return to the oven at 200 degrees Fahrenheit to slow cook until you attain 130 degrees interior temperature for a minimum of 30 minutes.
12. After removing from the oven, allow the meat to rest for 20 minutes before cutting across the roll (like cutting a jelly roll) to serve over a mound of wild rice.
13. Drizzle a reduction of red wine and chokecherry sauce over the top before serving.

Pair these two special South Dakota game meats with Valiant Vineyards' Wild Grape Wine, Valiant's signature wine that received a great review from Wine Spectator *and was even sold in Paris for eighty-seven euros.*

Venison Bourguignon with South Dakota Marquette

olive oil
3 strips thick-cut bacon
1 ½ to 2 pounds venison loin, cut into chunks (elk or moose would work, too)
1 large onion, sliced
2 stalks celery, chopped
3 carrots, chopped
3 cloves garlic, minced
½ cup port (choose a South Dakota port)
flour
salt and pepper (to taste)
2 bottles South Dakota Marquette
4 tablespoons butter
½ to 1 pound mushrooms, sliced
2 teaspoons cornstarch

1. Preheat oven to 350 degrees.
2. On the stovetop, heat enough olive oil to cover the bottom of a cast-iron Dutch oven. Heat to medium. Add bacon and sauté until bacon begins to brown. Remove and set aside.
3. Dry the cubed venison on paper towels.
4. Brown the meat in small batches in the olive oil/bacon drippings. Remove and set aside with bacon.
5. Cook sliced onion, celery and carrots in the drippings until soft—about 10 minutes. Do not caramelize. Add the garlic. Sauté another few minutes.
6. Add the port. With a spatula, rub the bottom of the pan so drippings blend into the port and veggies. Stir well to coat all the veggies.
7. Flambé port in pan by tipping up to pool port in the corner of the pan. Light to burn off the alcohol.
8. Lightly dust venison with flour. Return meat to the vegetable mixture in the Dutch oven. Also return bacon.
9. Add salt and pepper. The sauce will reduce, so go lighter on the salt.
10. Add one entire bottle of Marquette. If it doesn't cover the meat and veggie mixture, add up to one more cup from a second bottle of wine. (There should still be plenty of the second bottle to have with the meal. Can also add water or beef stock for extra liquid.)
11. Turn the oven down to 300 degrees Fahrenheit. Cover the stew. Simmer in the oven for 2–3 hours. The wine/port sauce should be reduced and thickened. If too much sauce reduced, add more wine,

beef stock or water at any point, remembering that water may dilute the flavor more than wine or stock.

12. After the 2–3 hours, melt 2 tablespoons butter in a pan on the stovetop. Sauté the mushrooms until they just begin to caramelize. Add to the stew.
13. Melt the last 2 tablespoons of butter. Add up to 2 teaspoons of cornstarch; stir into a paste. If reduction sauce is very thick, use less cornstarch. Add paste into stew.
14. Cook in oven 10 more minutes.
15. Serve! Can serve with corn bread or use the stovetop to make a creamy polenta. Could also boil or mash potatoes for side dish.

Pour a glass of Marquette used in the recipe for a natural marriage pairing. The earth and spice of the wine mimic the Pinot Noir grape—the grape of the Bourguignon region for which this dish is named and the grape that is the grandfather of Marquette. This traditional stew is perfect for South Dakota wild game and South Dakota Marquette wine.

Pheasant Balls with Naked Winery's Climax Chardonnay (traditional South Dakota recipe from Mrs. Nils Johnson, 1933)

scrape bony part of a pheasant and grind fine, mix with pepper and salt
1 cup sweet cream
½ cup dried, rolled bread crumbs

1. Mix ground pheasant, cream and bread crumbs well.
2. Drop in brown butter and fry. This can be quite soft.
3. Use more cream in mixture, if necessary.

**Note from 1933:"You can boil the bones and make soup. The meat that is left on the bone, cream and put on toast. Don't grind the breast if you don't like. Slice off the bone and dip in eggs and cream and bread crumbs and fry in butter."

Break all the rules by pairing this very old-fashioned South Dakota, Depression-era meal with a completely modern wine—Naked Winery's Climax Chardonnay. The buttery style of this Chardonnay will be a nice complement for the cream used in the recipe and the butter used for frying.

Swedish Soufflé of Leftover Fish with Tucker's Walk Brianna
(traditional South Dakota recipe from Mrs. Nils Johnson, 1933)

3 tablespoons butter
4 tablespoons flour
½ teaspoon salt
¼ teaspoon paprika
2 tablespoons finely chopped celery
1 tablespoon chopped onions
2 cups milk
1 cup cooked rice
1 leftover fish
3 egg yolks

1. Melt the butter and add the flour, salt and paprika.
2. Add the celery and onion, and when blended, add the milk and cook until a creamy sauce is formed.
3. Stir frequently to prevent lumping and scorching.
4. Add the rice, fish and egg yolks and beat for 2 minutes.
5. Fold in egg whites and pour into a buttered baking dish.
6. Bake for 30 minutes at 325 degrees Fahrenheit.
7. Carefully unmold and surround with creamed peas.

Revert to tradition by pairing this light and creamy meal with Tucker's Walk Brianna, made from hybrid grapes that grew well all over South Dakota. The fruity, semisweet wine with notes of pineapple is a nice contrast pairing for this customary Depression-era meal.

Desserts

South Dakota wines can be enjoyed from the beginning of every meal to the end, including dessert. The sweet wines of the state can be dessert in and of themselves, they can be used as an ingredient in the final course or they can be paired with the food. No matter the choice, there are many wonderful dessert wines to finish every meal.

Belle Joli's Pear Dessert Wine with Pear Crisp

8 large pears, cored and sliced—peel left on
1 tablespoon white sugar
1 tablespoon white flour
1 cup brown sugar
¾ cup old-fashioned oats
1 teaspoon cinnamon
½ cup cold butter

1. Mix together pears, white sugar and white flour in a large mixing bowl.
2. Pour into a lightly sprayed 9x9 baking pan.
3. Make crumble by mixing brown sugar, oats and cinnamon in another mixing bowl.
4. Use a pastry cutter or two forks to cut the cold butter into the oat mixture until blended into coarse crumbs.
5. Spread over the top of the pear mixture.
6. Bake at 350 degrees Fahrenheit in oven for 30–40 minutes, until the sides are bubbling and the crumble is a golden brown.

Create the ultimate dessert course with a small glass of Belle Joli's Pear Dessert Wine. The natural sweetness of the dessert brings out the natural pear flavor in the wine. Serve with wine chilled and crisp slightly warm. Substitute fresh peaches in the recipe for a peach crisp and substitute Belle Joli's Peach Dessert wine as the pairing—different wine and fruit, with the same delicious premise.

Chocolate Pots De Crème with Firehouse Wine Cellars Tradition Port

1 cup semisweet chocolate chips
2 tablespoons sugar
¼ teaspoon salt
1 egg
1 teaspoon vanilla
1 teaspoon instant coffee
1 tablespoon Firehouse Wine Cellars Tradition Port
¾ cup hot milk
whipped cream
raspberries

1. Add the first seven ingredients in the blender; slowly add the hot milk.
2. Cover the blender with a cloth to prevent splattering and mix well.
3. Pour into four to six demitasse cups or small ramekins (depending on their size). Refrigerate until set.
4. Garnish with real whipped cream and fresh raspberries.

Serve this deliciously easy dessert (that others will believe took hours to prepare) with a port glass of Firehouse Wine Cellars Tradition. The chocolate and the port will make a wonderful complement pairing; the port in the dessert is also a tasty marriage pairing. Chocolate in any form is a great accompaniment to port.

Spice and Date Cake with Valiant Vineyards Wild Grape Port
(traditional South Dakota recipe from Olga Bisgard, Waubay, 1930s)

1 ½ cups sugar
¾ cup butter
2 eggs
1 ½ cups sour milk
2 teaspoons baking soda
1 teaspoon cinnamon
1 teaspoon nutmeg
1 teaspoon cloves
3 cups flour
1 cup dates
1 cup nuts

1. Mix sugar, butter and eggs with hand mixer.
2. Add milk and mix again.
3. In a separate bowl, lightly blend all dry ingredients.
4. Add to the wet ingredients and mix well.
5. Stir in dates and nuts.
6. Pour into a greased and floured 9x13 pan.
7. Bake at 350 degrees Fahrenheit for 40–50 minutes, or until a toothpick inserted comes out clean.

The spice and sweet of this date-spice cake is a great dessert pairing with Valiant Vineyards' Wild Grape Port, made with wild South Dakota grapes and then aged fourteen years in barrel. The nuttiness of the aged port matches well with the nuttiness of the cake. This creates a traditional pairing perfect for traditional grapes from the state.

Appendix

SOUTH DAKOTA WINERIES

BAUMBERGER WINERY
47327 SD Highway 34
Dell Rapids, SD 57022
(605) 254-8986

BELLE JOLI' WINERY SPARKLING
HOUSE
3951 Vanocker Canyon Road
Sturgis, SD 57785
(605) 347-9463
bellejoli.com

BELLE JOLI' WINERY TASTING ROOM
594 Main Street
Deadwood, SD 57732
(605) 571-1006
bellejoli.com

BIRDSONG VINEYARDS
30820 472nd Avenue
Beresford, SD 57004
(605) 253-2132
birdsongvineyards.com

DAKOTA FALLS WINERY
719 North Splitrock Boulevard
Brandon, SD 57005
(605) 321-5532

FIREHOUSE WINE CELLARS
620 Main Street
Rapid City, SD 57701
(605) 716-9463
firehousewinecellars.com

NAKED WINERY—HILL CITY
23851 US-385
Hill City, SD 57745
(605) 574-2454
nakedwinerysd.com

PRAIRIE BERRY EAST BANK
322 East Eighth Street
Sioux Falls, SD 57103
(605) 496-7175
prairieberry.com/eastbank

PRAIRIE BERRY WINERY
23837 Highway 385
Hill City, SD 57745
(877) 226-9453
prairieberry.com

SCHADÉ VINEYARD AND WINERY
21095 463rd Avenue
Volga, SD 57071
(605) 627-5545
schadevineyard.com

STONE FACES WINERY
12670 Robins Roost Road
Hill City, SD 57745
(605) 716-9463
stonefaceswinery.com

STRAWBALE WINERY
47215 257th Street
Renner, SD 57055
(605) 543-5071
strawbalewinery.com

TUCKER'S WALK VINEYARD
48348 254th Street
Garretson, SD 57030
(605) 594-6287
tuckerswalk.com

VALIANT VINEYARDS
1500 West Main Street
Vermillion, SD 57069
(605) 624-4500
buffalorunwinery.com

WIDE SKY WINES
21091 First Avenue South
Bushell, SD 57276
(605) 690-1287
wideskywines.com

WILDE PRAIRIE WINERY
48052 259th Street
Brandon, SD 57005
(605) 582-6471
wildeprairiewinery.com

WITH THE WIND WINERY
10722 Lake Road
Rosholt, SD 57260
(605) 537-4780
withthewindwinery.com

BIBLIOGRAPHY

Abbott, Patrick J., MD. "American Indian and Alaska Native Aboriginal Use of Alcohol in the United States." *American Indian and Alaska Native Mental Health Research* (1996): 8.

Burrows, Rhoda, et al. "Wine & Grapes." *I Grow*, October 26, 2015. South Dakota State University. http://igrow.org/community-development/local-foods/wine-grapes.

Minnesota Grape Growers Association. "Cold Hardy Grape Varieties," 2016. http://www.mngrapes.org/?page=Varieties.

Prairie Berry Winery. Prairie Berry LLC, 2017. http://www.prairieberry.com.

Smith, Bruce. "History of the Early Swenson Hybrids." Presentation, University of Nebraska–Lincoln, 2016. http://viticulture.unl.edu/publication/Elmer%20History%20-%20Old%20Cultivars%20.

South Dakota Department of Agriculture, 2012. https://sdda.sd.gov.

South Dakota Legislature Legislative Research Council. "Chapter 35–12 Farm Wineries." South Dakota State Legislature, 2015. http://sdlegislature.gov/Statutes/Codified_Laws/DisplayStatute.aspx?Statute=35-12&Type=Statute.

University of Minnesota. "Cold Hardy Frontenac Blanc." Regents of the University of Minnesota, 2016. http://mnhardy.umn.edu/varieties/fruit/grapes/frontenac-blanc.

———. "Cold Hardy La Crescent Grape Variety." Regents of the University of Minnesota, 2016. http://license.umn.edu/technologies/z05103_cold-hardy-lacrescent-grape-variety.

————. "Cold Hardy Marquette Grape Variety." Regents of the University of Minnesota, 2016. http://license.umn.edu/technologies/z05103_cold-hardy-marquette-grape-variety.

————. "Frontenac Gris." Regents of the University of Minnesota, 2016. http://mnhardy.umn.edu/varieties/fruit/grapes/frontenac-gris.

————. "Minnesota Hardy." Regents of the University of Minnesota, 2016. http://mnhardy.umn.edu/varieties/fruit/grapes.

Van Balen, John. *South Dakota Chronology: From Prehistoric Times to 1899.* Vermillion: I.D. Weeks Library, University of South Dakota, 1998.

INDEX

ABOUT THE AUTHORS

DENISE DEPAOLO is a media professional living in Sioux Falls, South Dakota. She is a lover of wine, history and punk rock music. In her free time, she likes cooking for family and friends, learning new things and exploring South Dakota's diverse landscapes.

KARA SWEET is a veteran writing and language arts teacher in the Black Hills of Wyoming. She is also a sommelier through the International Wine and Spirits Guild and Certified Specialist of Wine through the Society of Wine Educators. In her free time, she enjoys hiking the Hills, reading great literature and traveling to wine destinations.